Gilles Weissmann

TECHNIQUES
OF TRADITIONAL
ICON PAINTING

SEARCH PRESS

First published in Great Britain 2012 by Search Press Limited,
Wellwood, North Farm Road, Tunbridge Wells, Kent TN2 3DR

Reprinted 2014

Original title: Les Icônes de Tradition Byzantine

© 2010 by ULISSÉDITIONS
15, rue Mansart
75009 Paris

English translation by Helen Stokes at Cicero Translations

English edition typeset by Greengate Publishing Services

ISBN: 978-1-84448-794-3

Photography: Gérard Boulanger, Gilles Weissmann
Models: Isabelle Archambault
Picture credits: Tretyakov Gallery, Moscow (pages 6, 13, 14, 22)

Publisher's note
Handle all pigments with extreme care and follow the supplier's advice. Avoid
inhaling the fine powder and wash any that gets on your skin as some are
toxic and even carcinogenic. Avoid ingesting any pigment and take particular
care when handling the cadmiums and lead-based pigments.

Printed in China

Note: Handle all pigments with
extreme care and follow the supplier's
advice. Avoid inhaling the fine
powder and wash any that gets on
your skin as some are toxic and even
carcinogenic. Avoid ingesting any
pigment and take particular care when
handling the cadmiums and lead-
based pigments.

Contents

Introduction 5

1 **Origins and principles 7**
The incarnation 7
The tradition of the holy image 8
The icon's pictorial language 12

2 **Tools and materials 17**
The panel 17
Drawing materials 18
Gilding materials 18
Painting materials 18
Pigments 19
Varnishes 19

3 **Choosing a subject 21**

4 **Preparing the panel 25**
Choice of wood 25
Preparing the support 26
Preparing the rabbit-skin glue 28
Beginning the gluing process 28
Attaching the fabric 29
Adding the gesso 30
Sanding 33

5 **Byzantine drawing 35**
The Byzantine style 35
Drawing on paper 40
Drawing with a paintbrush 44

6 **Gold 49**
Applying gold with oil-based size 49
Applying gold leaf using water gilding 51

7 **Colour and light 53**
The iconographer's palette 54
Opening the icon 57
Starting with the shadows 58
How the highlights are applied 61
Adding the highlights to your icon 64
Finishing the clothing 79
Finishing off 80
Using the dry-brush technique 81
Other icons stage by stage 86
Gallery 96
Gallery of students' icons 106

8 **Inscriptions 115**
Adding the name 115
Examples of inscriptions 117

9 **Olifa and varnish 121**
Olifa 121
Varnishes 122

Bibliography 125

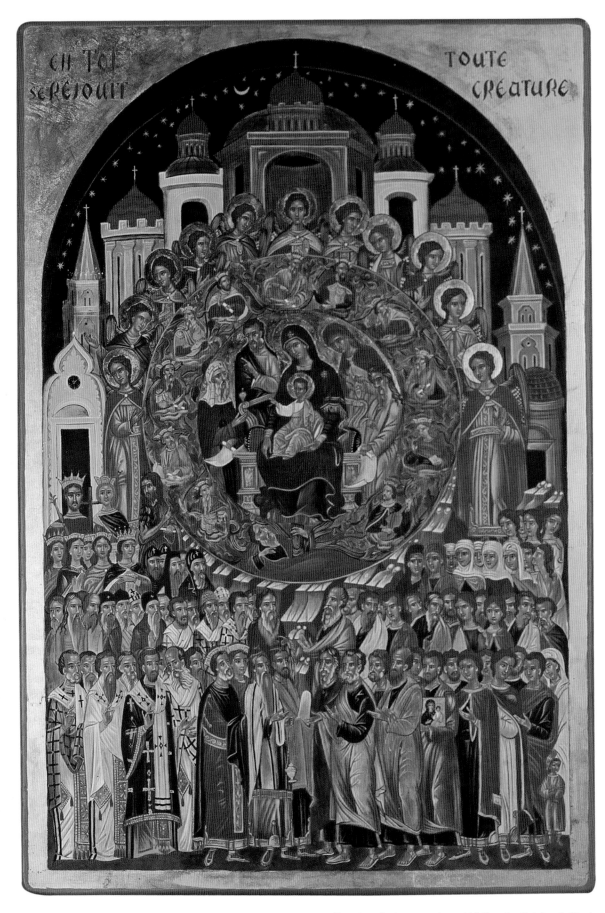

En toi se réjouit toute créature (All Creation Rejoices in You).

*I*ntroduction

The Byzantine Empire collapsed five centuries ago, so why does its unique art still flourish today, practised not only by Christians in the East but increasingly also by those in the West? What is it about an icon that appeals to us? Why should you paint one, and how should you go about it? This book invites you to find out.

An icon depicts one or more important Christian figures: men and women 'who have restored the original beauty of the human being' (George Drobot, iconographer) and who are depicted in a universe glowing with peace and serenity. An icon is a spiritual treasure for all humanity, which awakens our most intimate and essential nature.

Iconography offers a rich heritage, provided by the work of those who have chosen to share their knowledge of the eternal realities of the spiritual world. By carefully considering the influence of shape and colour on the human soul, they created a language capable of embodying these realities.

Byzantine painting teaches us about the invisible, about our strengths, and it evokes that which is everlasting. The icon is a meeting place between the divine and human realms; it helps us to find the sense of our lives. As iconographer Léonide Ouspensky said, 'not only do these images reveal to man a universe transformed, but they also allow him to engage with it'.

The icon speaks the language of a secret, forgotten region of the human soul; it reminds us of our own

Gilles Weissmann at work.

luminous nature and this is why, when we look at an icon, we feel a sense of recognition. Developed over many centuries, Byzantine pictorial language is testament to an extraordinary knowledge of form and the invention of a new kind of beauty, capable of impregnating matter with the sense and greatness of a message that is eternally young.

Part of the icon's symbolism is transmitted through the techniques used to create it. The meaning and content of the icon effectively determine the iconographer's style, materials, methods, stance and actions. In this way the stages of the painting constitute a symbolic rising from the shadows towards the lighter tones, achieved with finely worked, organised and well-chosen materials.

A living art, accessible to all
This traditional technique is not relegated to history; it has been passed down from master to student since its conception. Rediscovered at the beginning of the twentieth century, the icon has become familiar to an increasingly large number of people. Accessible to all, even to those who feel they cannot draw well, these traditional techniques require patience and perseverance above all.

Conceived as a practical guide to creating icons, this book aims to remain faithful to this authentic art. I hope that during your apprenticeship you will find pleasure in the joy of heaven on earth.

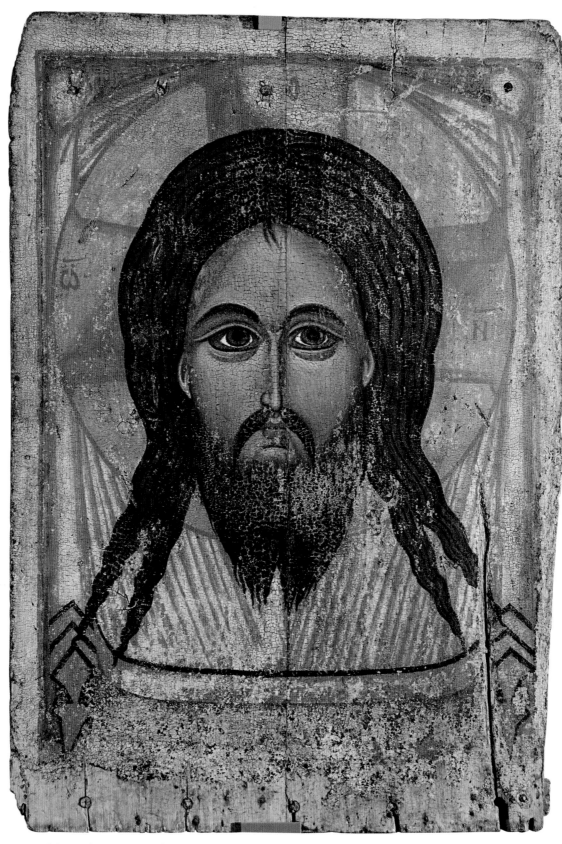

Mandylion, 13th century, Tretyakov Gallery. 'God became man so that man might become God' (St Irenaeus of Lyon). The icon of Christ 'restorer of the divine image in man' (iconographer Father Grégoire Krug) is the origin of all icons, which reveal the presence of the divine in sanctified man.

1 Origins and principles

The incarnation

The founding event in Christian iconography is the mystery of the incarnation of the Son of God. In becoming man, the invisible God became visible; it is therefore possible and indeed necessary to portray Jesus.

The first icon: the Mandylion

The legend recalls that King Abgar of Edessa, a leper, sent his archivist Hannan to ask Christ to cure him. Since Christ was unable to make the journey, Hannan tried to create His portrait, though he was unable to capture the appearance of the Saviour. Jesus washed His face and dried it with a piece of cloth and as He did so His features were imprinted on the Mandylion (handkerchief) which He handed to Hannan. When King Abgar looked at the image of the Holy Face he began to heal. Later Christ sent St Jude Thaddeus, the Apostle, to Abgar to help him recover completely and to convert all his people.

Abgar showed such great devotion to the icon that was not made by human hands, that he had it placed in a niche above the main gateway into the city, but when his grandson became king, the new king decided to destroy the icon. When the Bishop of Edessa learnt of the new king's intentions, he prevented the destruction by first placing a burning lamp in front of the icon and then sealing up the niche to preserve the image.

When Chosroes, King of Persia, besieged the town in 544, Eulalios, the bishop at that time, unblocked the niche and to his great surprise found that not only was the icon intact, but that after five hundred years the lamp was still burning. Moreover, on the tile that had sealed the niche, the bishop found the perfect replica of the image of the Holy Face: the Keramidion. The people of the city formed a long procession bearing the two holy prizes and the sight brought dread to the eyes of the besiegers.

The 7th Ecumenical Council of 787 and St John of Damascus make reference to the Holy Face, the icon that was not made by human hands, adding legitimacy to these images.

The emperor had the Mandylion and Abgar's letters transferred to Constantinople (now Istanbul) on 15 August 944. The icon was the object of great veneration until the sacking of Constantinople by Crusaders in 1204, at which point it mysteriously disappeared.

King Abgar, after an icon of the 10th century.

The icons of Saint Luke

Saint Luke, the evangelist and doctor, is traditionally regarded as the first iconographer: he is thought to have painted three icons of the Virgin Mary. Around forty icons around the world have been attributed to his hand.

Saint Luke Painting the Icon of the Virgin, by Geneviève Gouverneur.

The tradition of the holy image

In the words of Annick de Souzenelle, 'Tradition, by its nature, is seen as a great veiled lady, whose veils we must remove gradually, one by one, as we experience our own interior transformation. Tradition is a form of transmission but, contrary to popular belief, it does not carry a message belonging to the past, but a presence which is revealed little by little and which transforms our present. Those who wish to preserve tradition have completely misunderstood the concept, since it is constantly evolving.'

For the Church of the East, liturgical art represents heaven on earth; iconography as well as the liturgy, architecture and plain chant form a harmonious ensemble under this single overriding principle. The icon is believed to reflect its heavenly model or prototype – it is not an object of idolatry, but a conduit.

The creation of Marian icons (which depict the mother of Christ) does not date back to the painters but to the Holy Fathers of the Church and they then serve as models in their turn. Their authenticity is bound to their fidelity to the subject, and the strict iconographic rules protect the integrity of the message. These unwritten rules, which were passed down through oral tradition and by example, can be learnt by study and practice. This book is drawn from such rules.

The iconostasis

The iconostasis is the screen that separates the nave from the sanctuary in Byzantine churches and on which icons are attached in a certain order. The screen acts as an intermediary between the physical world and the invisible, spiritual world it portrays.

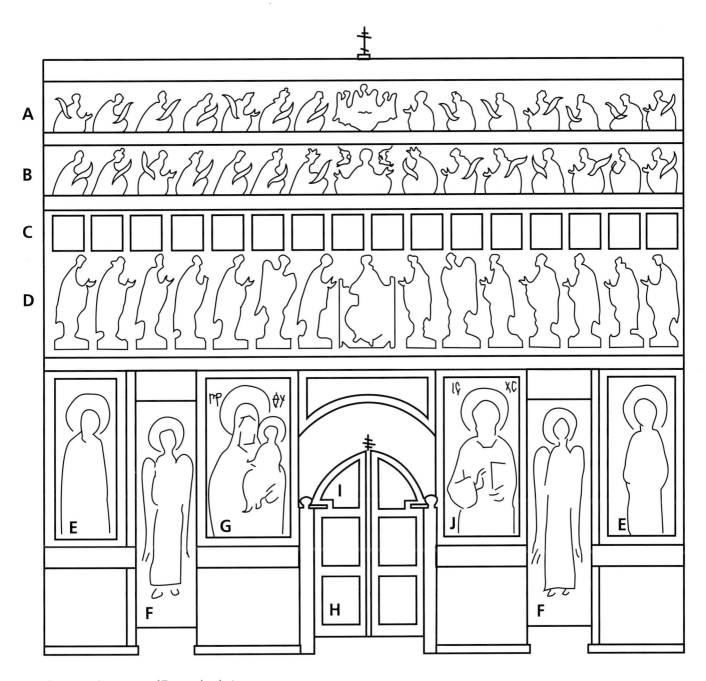

Iconostases (nave screen of Eastern churches)

A: Patriarchs
B: Prophets
C: Important feast days
D: Deisis
E: Local saint

F: Archangels Michael and Gabriel
G: Mother of God
H: Evangelists
I: The Annunciation
J: Christ

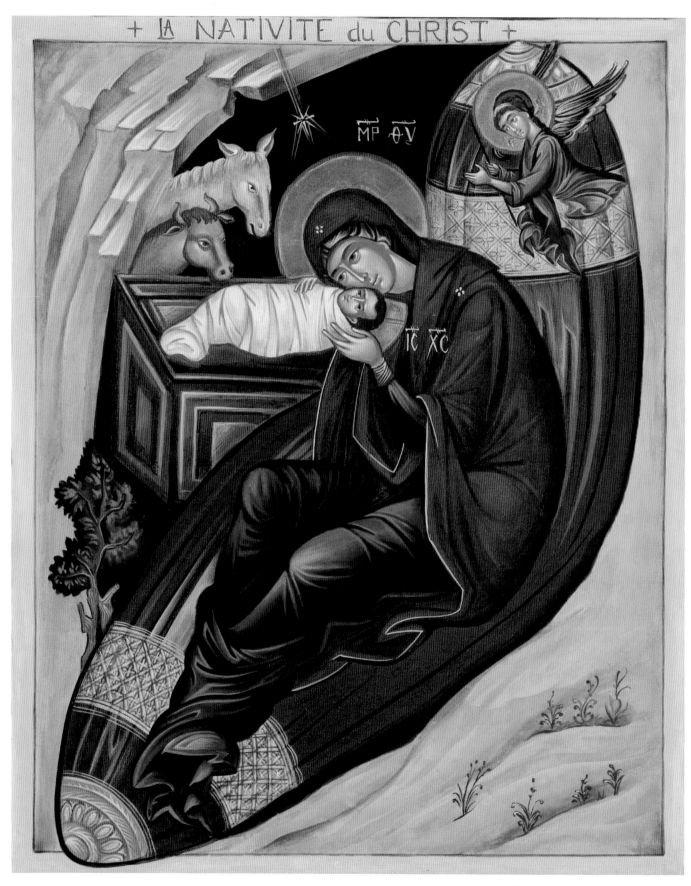

The Nativity, by Geneviève Gouverneur.

The twelve great feasts

We have already seen that there are icons of Christ, Marian icons (of the Virgin Mary), and those of saints and angels, as shown on the iconostases. Another main category comprises the feast icons, each associated with a feast celebrated during the solar calendar, which is itself a symbol of eternity. In addition to the Feast of the Resurrection of Jesus, there are twelve great feasts in the liturgical year which celebrate the essential stages in the incarnation of Christ:

- The Nativity of the Virgin Mary
- The Presentation of Mary to the Temple
- The Annunciation
- The Nativity
- The Presentation of Jesus to the Temple
- The Baptism of Christ
- The Transfiguration
- The Entry into Jerusalem
- The Ascension
- The Exaltation of the Cross
- The Dormition
- Pentecost

'The spoken words of the Evangelist are represented and made present by the icon.'
(Ecumenical Council 869/870)

The presence

In churches that follow the Byzantine Rite, icons are venerated and the subject of chants. Worshippers kiss the holy icons on lecterns and they light candles in front of them, prostrate and cross themselves. This type of worship, which rises through the visible to the invisible, is directed not to the object itself but to what it represents. Icons are also found in all Orthodox homes; they are spaces in which grace is present and their contemplation is sanctifying, they help us 'maintain our faith with our eyes'.

The iconographer

Although the iconographic artist can take pride in the originality of his work, his aim is to produce an icon capable of transmission – able to act as a conduit to the figure it depicts. As Higoumène Barsanuphe said, 'Icons have been canonised by all of God's people; if an icon departs from the models accepted by the Church and in front of which prayers have been said, it is no longer an icon.'

The iconographer takes part in the life of the Church, he fasts, he confesses, he receives communion and he works in silence and prayer. He puts his talent at the service of the tradition, which demands great humility. He must make himself transparent so that enlightenment can pass through, 'but at the same time, the iconographer's character is transformed by the response received from on high, and this makes him even more open to the truth' (iconographer Father Georges Drobot).

The iconographer's freedom of expression and creation is much wider than is often thought, as is apparent in the infinite variations on the same subject seen in ancient icons. He is like a musician who, without changing the score, brings new life to a part through his own interpretation. As well as following the examples of the masters, it is his spiritual life and his relationship with the subject that will inspire harmony in the icon. Through his being, a new image, born from living tradition, will become real.

The art of iconography has much to offer the artist. As iconographer Geneviève Gouverneur says, 'Today's iconographers and those who have gone before them tirelessly copy the image of a restored world. That is why icons can set those who appropriate the image through practice and contemplation on the path to healing.'

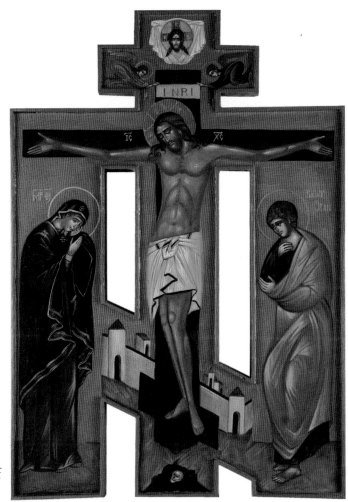

The Crucifixion, by Geneviève Gouverneur.

11

The icon's pictorial language

The founding dogmas of the holy image determine not only its existence but also its conception and style.

Conception

The artistic language of the icon was developed between the 1st and the 10th centuries. Between 730 and 843, the Byzantine Empire experienced a profound crisis which revealed the importance of the role of the icon. The rejection of idolatry and the fear of paganism drove emperors to prohibit icons and other such images. In the years that followed, the elite across the empire became iconoclasts who destroyed religious images where they found them, while the people and the monks remained iconophiles and tried to protect the icons. This conflict of ideas resulted in persecution, torture, execution, exile and the destruction of a huge number of icons, and forced theologians to reconsider the role of the image for almost a century, but eventually the destruction stopped and icons could be brought back out into the open. The iconoclastic period had a considerable influence on the aesthetic of the icon and, as a result, certain artistic canons were established. A new and recognisably Christian style emerged. It was a synthesis of Classical art and the art of the Middle East and it reinvented the representation of man and his surroundings.

Iconic style

The art of the icon must always create the illusion of the real; it establishes its mystical realism through the highly stylised 'artificial' techniques, in which each stroke, each shape and each colour is connected to the whole and made subordinate to its meaning. It is a simple style that evokes the three distinct stages of its production – the drawing, the colours and the light (the gilding and the highlights) – which are unified in the eyes of the viewer.

Symbolism

Symbolism is the expression of invisible spiritual realities through visible material realities. Byzantine painting proceeds towards a formal spiritualisation of its subjects and the elements of the composition. The icon goes beyond the historical event depicted to express the eternal idea, the interior truth behind it. The key to the symbolism is the idea that Byzantine art is the mirror of the kingdom of heaven.

Beauty

Although highly structured, the art of the icon does not follow simple formulas. It reconciles the purity of the form, which corresponds to reason, with the splendour of colour, which is the incarnation of love, in order to direct the viewer's gaze through beauty to the divine. Icons always reveal divine presence in creation, shining out towards the viewer.

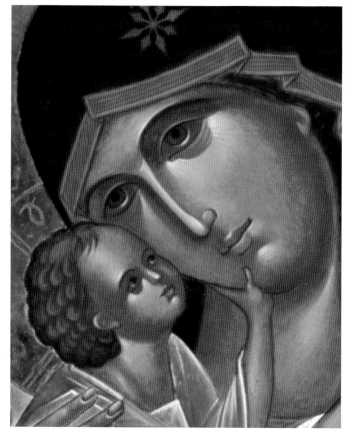

Virgin of Tenderness.

The icon's aesthetic expresses the incarnation through the balance and solidity of the composition, the fullness of shapes, the dynamism of the lines. It represents transfiguration through the transparency and explosion of colours, the omnipresence of light, the suggestion of divine guidance in the drawings of beings and fabrics, allegorical buildings and shimmering mountains. In every element of the icon, discipline and radiant joy unite to transmit life.

Light

Liturgical cycles, like the cycles of life itself, are ruled by the movement of the sun. The great feasts celebrate light: its rebirth at Christmas, its triumph at Easter, its revelation at the Transfiguration. The divine light reveals the truth just as the sun gives us the means of seeing the material world. It seems to emanate from shapes or to penetrate them; scattered over the surface of the image, it gives the impression of life in motion. The Light, which is the name given to the gold background and the small areas of white hatching, represents heaven, the realm of the saints, the mountains and God's architecture. The Light is the subject of all icons.

Transparency

As Titus Burckhardt says, 'According to a spiritual vision of the world, beauty is none other than the transparency of its existential layers: true art is beautiful because it is true.'

The icon's style plays on the contrast between the transparency of the first few layers of paint that suggest an interior light by reflecting off the white gesso, and the opacity of the highlights and last shimmers, passing through the semi-transparency of the blended colours.

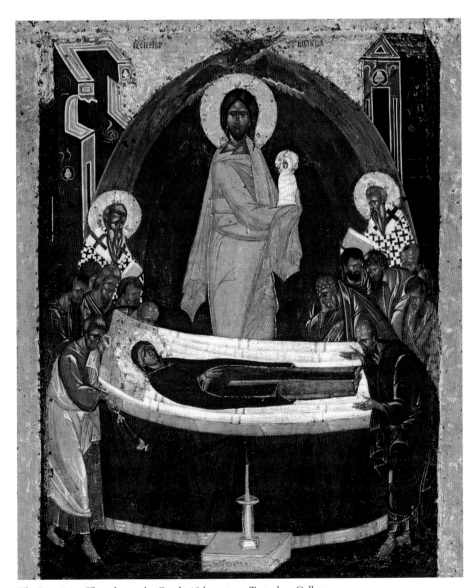

The Dormition, Theophanes the Greek, 15th century, Tretyakov Gallery.

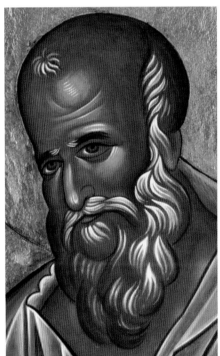

Saint John the Theologian.

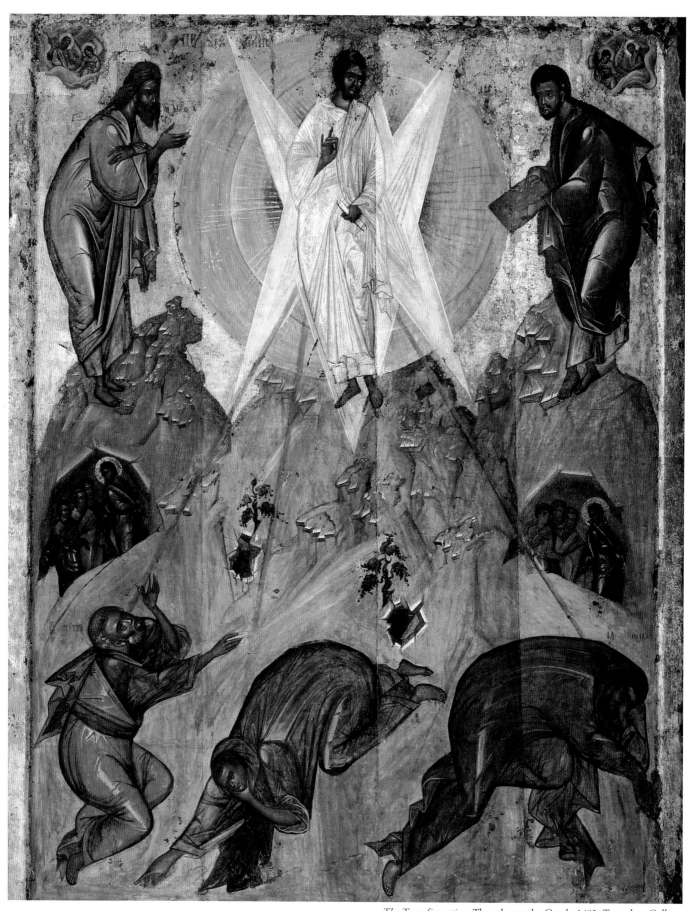

The Transfiguration, Theophanes the Greek, 1403, Tretyakov Gallery.

Man

Man is portrayed as free, a bearer of a grace 'which consumes passions and sanctifies all'. Figures are depicted transformed, refined, bearers of light, both present and detached, animated by calm postures. Their eyes, noses, mouths and ears are turned to face inwards. The folds of their clothing reveal the nature of their being. The objects, attitudes and colours that are traditionally attributed to them reveal the particularities of their spiritual life.

Space

The representation of space in Byzantine iconography symbolises a unique conception of the world. It suggests a reversal of viewpoint. What has, for a long time, been mistakenly described as awkwardness or naivety of style is in fact a developed and self-conscious artistic approach. The image space does not recede into the support but projects outwards. It is the celebrated use of inverted perspective that creates the sense of presence emanating from the icon: figures, furnishings and buildings seem to come forward to meet the viewer's gaze. It is not that we, the viewers, regard the icon, but that the icon looks out at us!

Time

Icons represent the feasts of history, but each celebration is an updating – a rehappening – of the event. The icon's space is free from the constraints of time; it can play host to events which take place at different moments, particularly during certain feasts. The Christ child is the size of a baby but has the body of a ten-year-old child. The historical event is overshadowed by the eternal meaning of its message and may return to the present through the contemplation of its depiction. This is the time of inner man, symbolic time, time outside time itself. Thus the icon allows us to be contemporary with Christ; it allows Him to enter into our present.

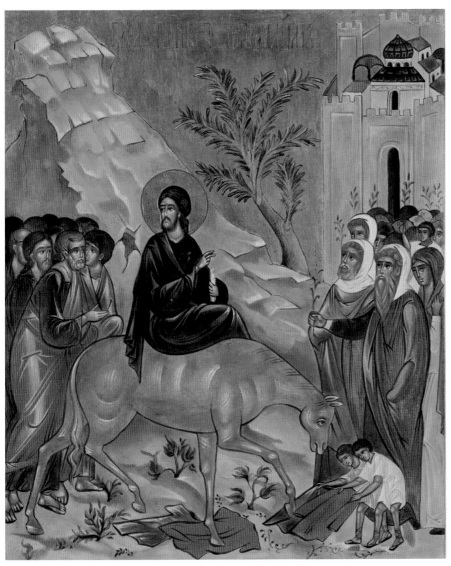

Entry of Christ into Jerusalem, by Geneviève Gouverneur.

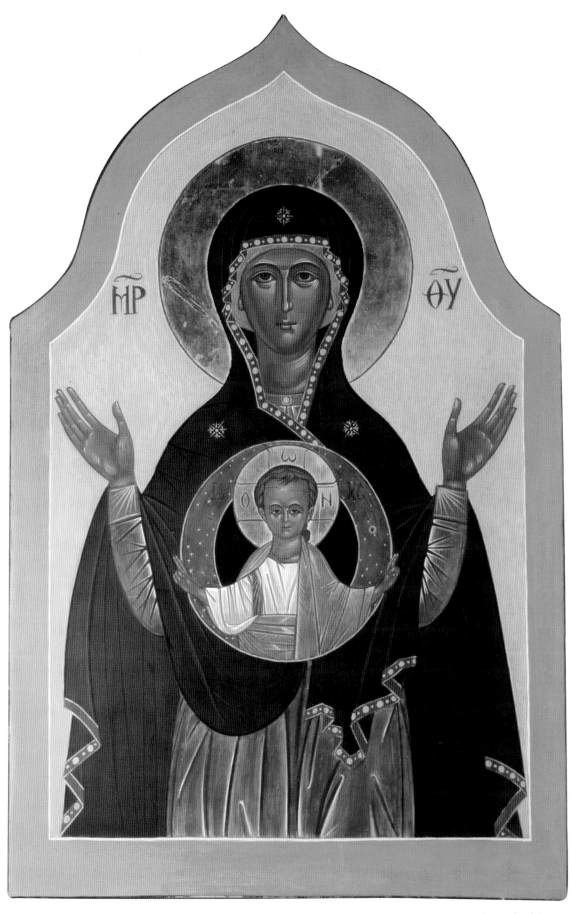

Our Lady of the Sign.

2 Tools and materials

An icon is designed to last for centuries, so its materials must be chosen and worked with great care. Materials and technique are also important because the icon's physical appearance has a major role to play in its effectiveness: inspired by the Spirit, earthly materials are transformed in the making of the icon. These materials are all natural: vegetable (the panel), animal (the rabbit-skin glue) and mineral (the gesso, gold and paint). We use natural materials or materials that have been minimally altered by industrial processes because it is these which bear witness to the fullness of creation; their vibrations sound in harmony with the grandeur and sobriety of this art.

The relationship between the iconographer and his materials is meaningful: it is as if the iconographer hears its possibilities, its reactions. In order to render it sublime he must first understand it. His art is made rich through careful observation and by following the ancient practices of iconic painting.

The panel

Wood is the 'vegetable' element in the creation of the icon. Its symbolism is linked to that of the tree, which suggests growth and unifies the sky (heaven) and earth. It is universal and highly present in Christian art. The solidity, longevity, durability and relative lightness of wood have made it the most common support for Byzantine iconography. Wood seems to breath, expanding or contracting according to changes of temperature and levels of humidity.

Materials for the preparation of the panel
- Gesso (levkas), made from whiting and rabbit-skin glue, is applied to the panel to provide the working ground (see page 30). This is the panel's second skin. It provides a perfectly smooth, white painting surface, which is absorbent enough to take on the colours brushed over it and sufficiently non-absorbent to allow the paint to pool, as is required for the 'little-lake' method (see page 58). Its whiteness lets light illuminate its internal colours.

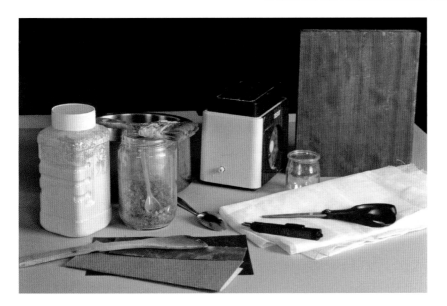

A wooden panel and some of the materials you would use to prepare it for painting.

- Rabbit-skin glue for sticking the cloth to the panel and for the gesso and gilding. It is strong yet flexible and can withstand any warping or movement in the wood. It is available in pellet, granule or powder form, and each panel requires roughly 50 grams (2oz).
- Whiting, an ingredient of gesso, is calcium carbonate (limestone chalk). You will need a 1kg (2¼oz) bag.
- Fabric to cover the panel and provide a key for the gesso. Tarlatan (starched muslin) is traditional and it is easy to apply. Alternatively, you can use fine cotton, linen or even silk.
- Flat brush for applying glue and gesso. It should be a large size with hog bristles – the sort normally used for house painting.
- Sandpaper to smooth the gesso. It should be good quality and waterproof. You will need one sheet each of the following grit sizes: 80, 200, 400, 600 and 1000. If you cut a sheet of sandpaper (do not use scissors!) or tear it into three equal pieces, it can be used with a sanding block.
- Sanding block to keep the sandpaper smooth. Alternatively, you can use a flat block of wood.
- You will also need weighing scales, scissors, a 750ml (26fl oz) glass jar, a stick or wooden spoon, a craft knife and an apron.

Drawing materials

- Technical pencil, such as a 0.5 or 0.7 Rotring pencil, is ideal for drawing on paper.
- Ink or putty eraser.
- Sanguine crayon for transferring the design to the panel.
- Drawing paper, tracing paper and masking tape to hold the paper.
- Ruler, a pair of compasses, set square and calculator for plotting the composition accurately (see chapter 5).

Gilding materials

- Gilders' bole.
- Armenian bole (a type of very thin red clay).
- Rabbit-skin glue.
- Sandpaper.
- For oil-based size (see page 49) you will also need a booklet of suitable gold leaf, plus size or flat varnish and shellac for varnishing.
- For water gilding (see page 51) you will need a gilder's cushion, gilder's knife, water brush, tamping brush, a booklet of loose gold-leaf sheets and an agate burnisher.

Gilding materials: boles, size, gold, agate burnishers, gilder's cushion, brushes, varnishes, abrasives and scissors.

Drawing and planning materials: pencil, sanguine crayon, rubber, a pair of compasses, ruler and set square.

Painting materials

- Sable brush: this is the icon painter's most trusted tool. It is used to draw, to hatch, to paint and to shade. There are many excellent brands of sable brush, such as Kolinsky, which specialises in high-quality hand-made red sable brushes. For the purposes of icon painting, the brush should be round with a good width and a very fine tip. Often larger brushes (size 5 or 6) have a finer tip than smaller brushes. Two brushes will be sufficient to start off with, such as a no. 3 and a no. 5.
- Grey squirrel-hair brush designed for watercolour or tempera. This is also round and pointed, but it is less firm and flexible than the sable brush. It can be used to cover large areas.
- Small, stiff hog-bristle brush for mixing pigments. Buy three or four.
- Small synthetic brush to use as a corrector brush.
- Palette and small containers or a few sea shells to prepare the tempera.
- Two dropper bottles: one of 3cl (1fl oz) for the emulsion and one of 6cl (2fl oz), 9cl (3fl oz) or 12cl (4fl oz) for water.
- Glass jars to clean the brushes.
- A small spirit level to ensure that the panel is completely flat (see page 58).
- Cotton buds and paper tissues.
- Small knife to scratch into dry paint.
- Ox gall for painting on gold (this can be substituted with saliva).
- Small bridge (see the illustration opposite) to enable you to work without touching the panel.

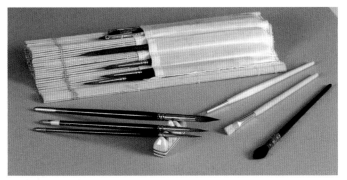

Selection of paintbrushes suitable to your needs.

Pigments

These are finely crushed coloured powders derived from mineral, plant or animal substances. See pages 54–56 for a list of essential pigments. Because many pigments are toxic, keep a few spoons for measuring out the pigment which are never used for any other purpose.

Varnishes

Shellac varnish, olifa (see pages 121–122) and oil varnishes may be required. You will also need a soft, flat paintbrush for varnishing.

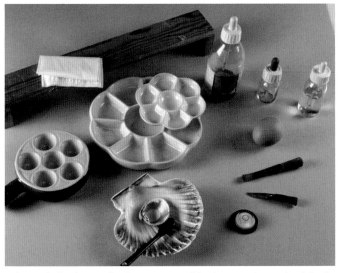

Palettes, shells, dropper bottles, tissue, small bridge, round spirit level, knife, cotton swabs, egg and ox gall.

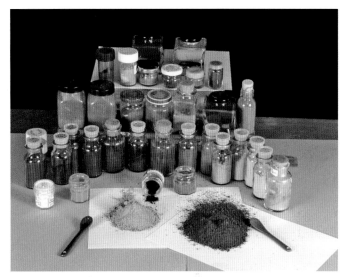

Pigments and measuring spoons.

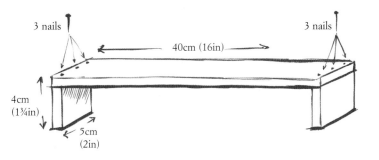

3 nails

3 nails

40cm (16in)

4cm (1¾in)

5cm (2in)

Use this diagram to make a small bridge out of wood, gluing and then nailing the pieces together.

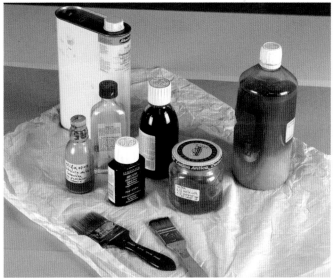

Varnishes and suitable brushes.

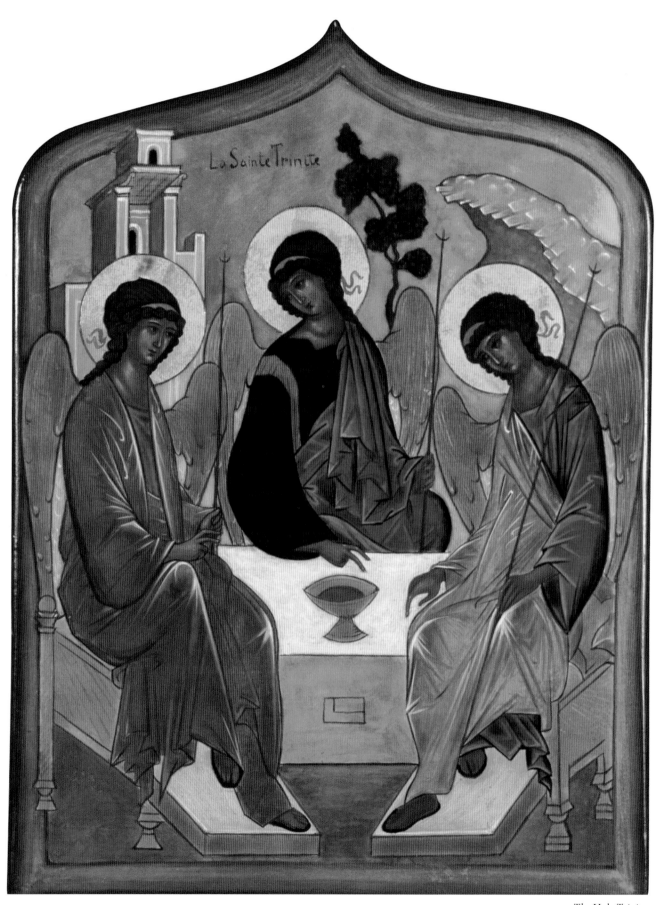

La Sainte Trinité

The Holy Trinity.

20

3 *Choosing a Subject*

A dedicated and experienced iconographer once travelled to a monastery in Greece. On the first day she announced her love for icons of John the Baptist and the pleasure she derived from painting them. The mother superior replied: 'You do not choose the saint you are going to depict, it is the saint who chooses you!' This is inverted perspective.

A meeting

An icon is a meeting point. The best way to understand this is to come directly into contact with an icon in a church or at an exhibition when possible, to experience light emanating from the sublime materials. Without thinking of anything in particular, allow yourself to be gazed upon by the icon. We are fortunate to be able to make use of beautiful books of icon painting, but a photograph cannot re-create the sense of presence. However, silent contemplation of beautiful icons, old and new, seen in person or in print, will help with later study of reproductions. Since the traditional method of icon painting uses natural pigments, it is possible to 'correct' the colours on printed and photocopied reproductions.

Choosing a subject

Start by working from an original icon or a copy of it. The most interesting date from the golden age of the icon: from the 13th to 15th centuries. When working from a copy, it is important to choose a good-quality reproduction, and to study other examples of the subject.

Listening

The icon 'talks' to us, but we can only hear a small part of what it tells us. To improve our receptiveness, we also need to listen to the texts to which it corresponds. With time we can improve our understanding.

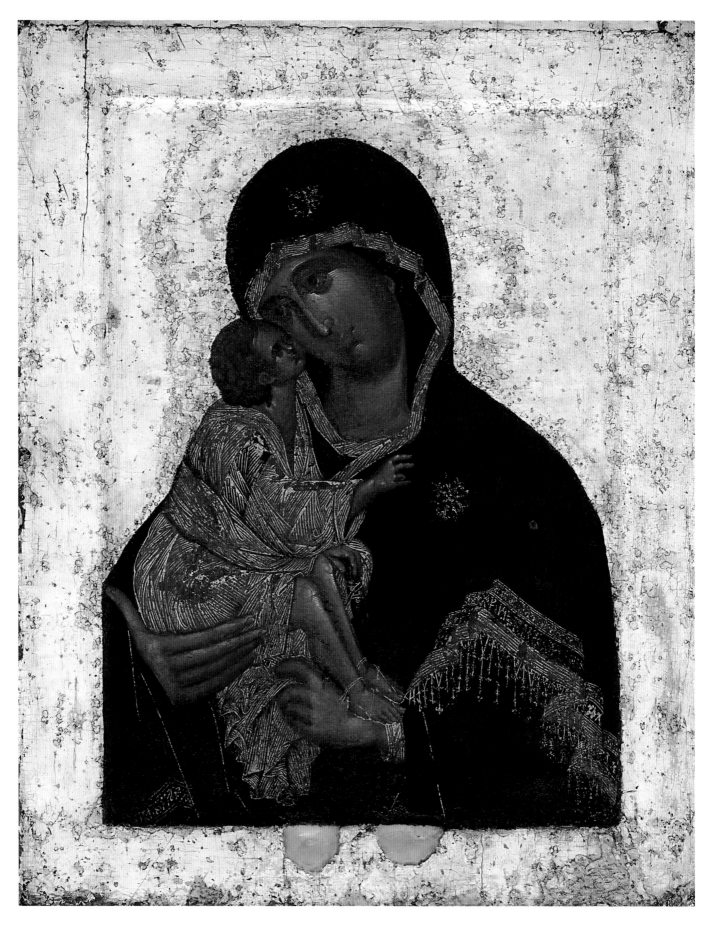

Creating a likeness, not an imitation

To begin our study of iconography, I have chosen a famous and highly venerated ancient model, *Our Lady of the Don* (shown left), which we shall be painting stage by stage. Is it an original or a copy? Its spirituality has touched a great number of hearts.

An icon's authenticity derives from its likeness to its model in the heavens, so we try to ensure our icon closely resembles the original. Our work is far from close copying, however, since it leaves room for inspiration. Iconography subtly transforms our normal way of thinking. Note that the conflict between creative originality and servile copying is quite a recent artistic idea, and let us remember that all good apprenticeships pass through a stage of imitation.

The icon we work from will be our teacher, but not a subject of idolatry: we will not copy it slavishly but in our own way. It is like a new interpretation of a piece of music. Is it not better to offer others resemblance to a good model rather than a mediocre copy of an original?

When copying an icon, the iconographer does not see himself as an artist. Instead he partakes in a shared heritage which exists around his art. In the words of iconographer Father Grégoire Krug, 'icons are not mechanically reproduced, but are born from each other'. Let us make our attempt without fearing for likeness because divine resemblance is an attribute only of the saints.

Although the image of God has been given to us, its likeness calls for our participation.

The iconographer's prayer

O Divine Lord of all that exists, enlighten and direct our souls, our hearts and our spirits;
Guide the hands of your servant so that he may worthily and perfectly portray your image, that of your Holy Mother and of all the saints,
For the glory, joy and adornment of your holy Church.

Opposite: *Our Lady of the Don*, Theophanes the Greek, 14th century, 86 × 68cm (34 × 26¾in), Tretyakov Gallery.
'"Whoever does the will of God is my mother..." These words mean that every man is given the grace to bring forth Christ in his soul, to identify himself through a spiritual analogy with the Theotokos.' (Paul Evdokimov)

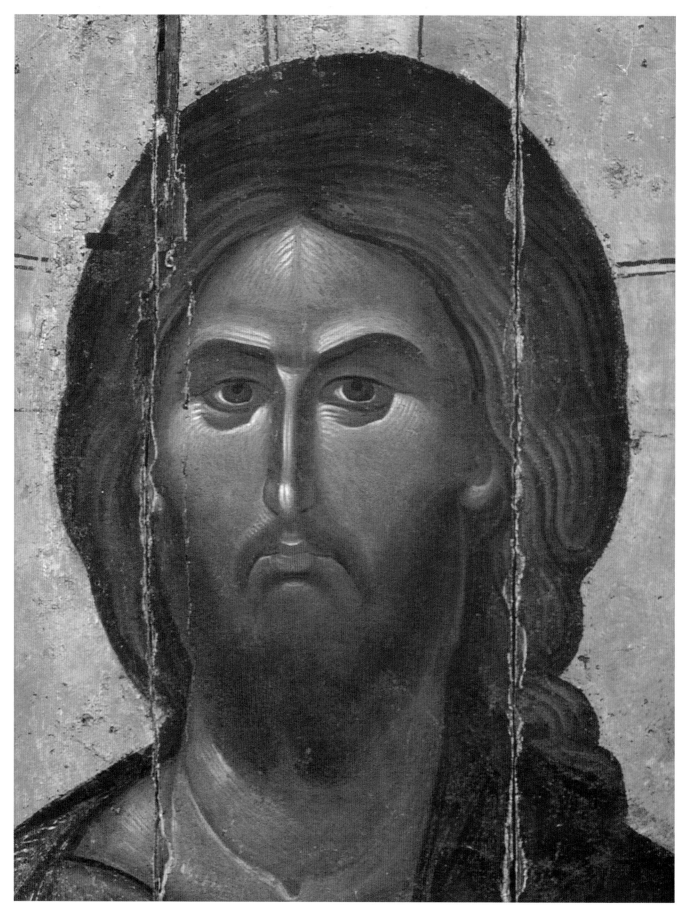

4 Preparing the Panel

Materials
- Rabbit-skin glue
- Flat brush
- Whiting powder
- Tarlatan (starched muslin) or cotton fabric
- Glass jar
- Sandpaper and sanding block
- Craft knife

Choice of wood

The types of wood most often chosen for icons are lime, poplar and beech. Panels must have been dried for at least six years; they must be very flat and of regular thickness, which should be at least 2cm (¾in). Paint is always applied to the heart side (the side that was closest to the centre of the tree when it was growing).

Paint is always applied to the heart side of the panel.

Because it is difficult to find suitable wood, to cut it and plane it, dry it flat and so on, it is better to buy the wood from a specialist who deals with panels for icons. You can also buy wooden panels already treated with gesso on both sides.

Plywood, which is less natural but more 'controlled', is also an economical and practical support.

Opposite: *Christ Pantocrator* (Christ, Ruler of All), 13th–14th century, Vatopedi Monastery, Mount Athos.

Preparing the support

Now we can begin work on the icon. Icons often have specific proportions: 2 × 3, 3 × 4, 4 × 5, 1 × 3 etc. which must be respected, so choose a panel with the same proportions as the interior frame of your model (see page 40).

If the dimensions of the interior frame are: 16 × 24cm (6½ × 9¾in), this is a ratio of 2 × 3. Your panel could also measure, for example: 12 × 18cm (4½ × 6¾in), 20 × 30cm (8 × 12in) or 30 × 45cm (12 × 18in) etc. Add a frame to your panel, if desired (see opposite) and then proceed to prepare the panel as follows:

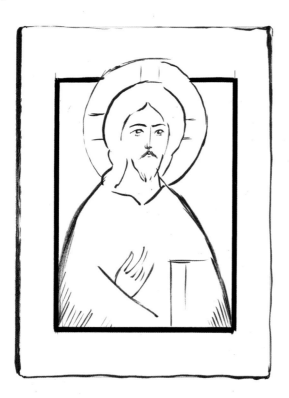

1 Once the panel has been cut to shape, smooth its edges and sand down the corners to be as rounded as you like using a medium-grit sandpaper, such as no. 80 (see photograph 1).

2 Score the panel on the side to be painted using a craft knife, with lines approximately 1cm (⅜in) apart and then score again at right angles, as shown photograph 2, to provide a good key for the glue.

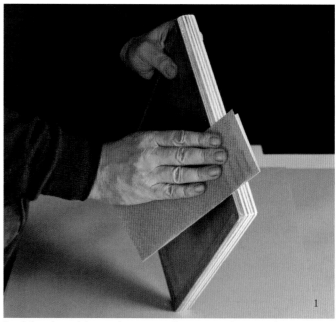

Sand the edges of the panel using a medium-grit sandpaper such as no. 80.

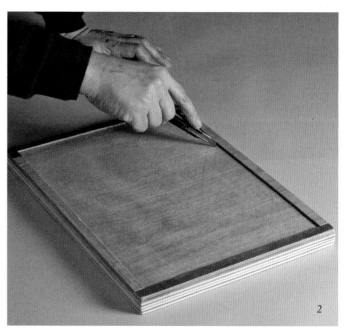

Using a sharp craft knife, score the panel on the front to provide a key for the glue. Score diagonally, first one way and then the other.

Making a hole for hanging

To hang an icon on a wall, use a 1cm (⅜in) diameter wood bit to drill a hole 1cm (⅜in) deep in the back of the panel, 3cm (1¼in) from the top edge and centred between the sides (see the illustration, right). Being able to hang the icon will prove very useful for observing your progress as you work because it will enable you to step back and see the icon from the usual viewing distance.

Creating the look of a hollowed-out panel

If the icon you are copying is painted on a panel that has been hollowed out, it is possible to use one yourself, ideally getting a professional to do the job for you. Alternatively, you can create the look of a hollowed-out panel by gluing wooden strips around the edges as follows:

1 Cut wooden strips 2–4mm (⅛–¼in) thick to fit around the edge of the panel like a frame, always remembering to maintain the proportions of the interior frame (see the points on page 40).

2 Apply suitable glue to the framing pieces and place them on the panel under a heavy weight while the glue dries – a pile of books works fine.

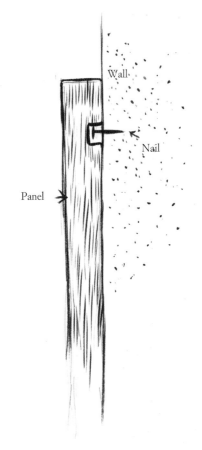

Drill a small hole in the back of the panel to enable you to hang it from a nail. The hole should be 1cm (⅜in) across and 1cm (⅜in) deep.

Create the look of a hollowed-out frame by gluing on wooden strips around the edges.

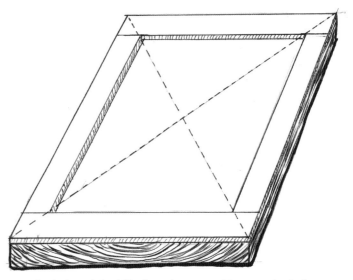

Your finished panel should be flat and square, and it must maintain the proportions of the interior frame.

Preparing the rabbit-skin glue

Rabbit-skin glue is an animal-based substance, which guarantees adhesion between the wood, fabric and the gesso.

Soaking (6 hours)

1 Using a glass jar, soak the rabbit-skin glue (granules or flakes) in ten times its weight of water. For example, 50g (2oz) of glue will require ½ litre (1pt) of water in a 750ml (1½pt) jar.

2 Allow the glue to swell overnight (minimum 6 hours).

Heating the glue in a bain-marie (10 minutes)

Cover the bottom of a saucepan with a piece of fabric or similar, then place the jar of glue on the fabric, add water to the saucepan and put it on the hob to heat up. Do not allow the glue to boil as this will weaken it. The glue will liquefy quite rapidly. This substance is the base glue at 10%. The glue should always be applied warm.

Storing the glue

Cover the glue and store it in the fridge, as if it were perishable foodstuffs, for up to a month.

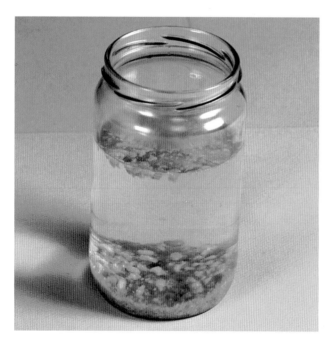

Above: Soak the glue granules or flakes in a jar covered in ten times their weight of water.

Above right: Place the panel on a book or something similar to enable you to apply the glue to the front and sides. Dab the glue to force it to penetrate the fibres of the wood.

Right: Apply the warm rabbit-skin glue to the front and sides of the panel first. When this is touch-dry, apply it to the back.

Beginning the gluing process

Rabbit-skin glue is a clear glue with great adhesive strength – so it is important to protect your worktable while you work. Place a book under the panel before you start to enable you to apply the glue to the sides of the panel using a decorator's paintbrush.

1 Apply the warmed glue to the sides and front of the panel, making sure it is distributed evenly. (This is very important.) Then tap over the surfaces using the brush at right angles to the panel to force the glue to penetrate the fibres of the wood, as shown in the photograph below.

2 When the glue is touch-dry (about 4 hours), turn the panel over, heat up some more glue and apply it to the back. There is no need to tap the surface with the brush but do make sure that you apply an even coat. Leave the glue to dry for 6 hours.

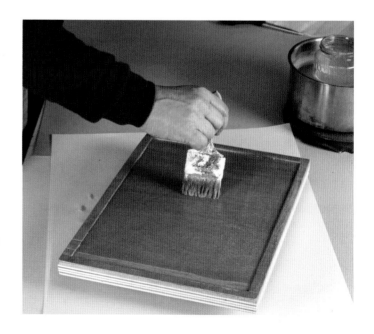

Attaching the fabric

The fabric ensures adhesion between the panel, which has a tendency to warp due to temperature and humidity changes, and the gesso; it is not essential for smaller icons. Tarlatan (starched muslin) is the most commonly used fabric for this process because it is easy to mount, but a piece of fine cotton or linen is also suitable. Allow ½ hour to apply the fabric plus 6 hours drying time.

1 Cut the fabric to the size of the panel, adding enough excess to cover the sides generously. Heat up the glue and apply it to the sides and front of the panel.

2 Place the fabric on to the glued panel. Starting in the centre and working outwards, pat the fabric with the brush loaded with glue in order to soak the fabric (see photograph 1). Regularly dip the brush into the glue. This method avoids creating any wrinkles in the fabric.

3 Once the whole of the front has been glued, work on the sides, again using plenty of glue and dabbing with the brush at right angles to the surface (see photograph 2).

4 Set the panel aside to dry completely. Finally, you can remove the excess fabric by rubbing the edges of the panel with no. 80 sandpaper (see photograph 3). Make sure that the back of the panel is smooth and flat.

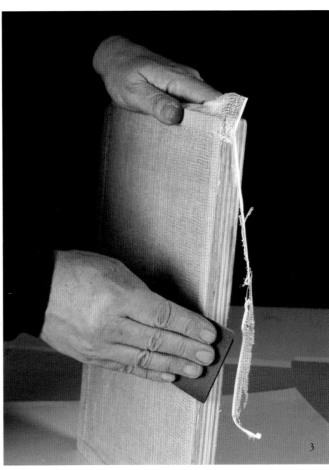

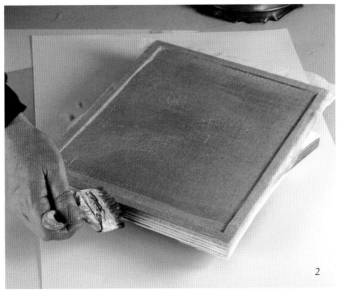

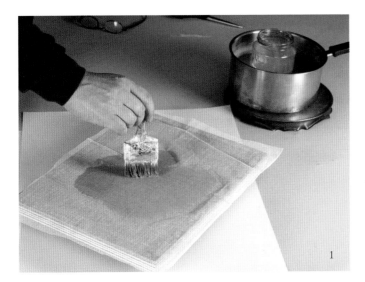

Top left: Dab warm glue over the fabric-covered panel, starting in the centre and working outwards to prevent creases from forming in the fabric.

Bottom left: Once the fabric has been glued to the front of the panel, work on the sides.

Above: Once the glue is completely dry, you can sand away the excess fabric from around the edges.

Adding the gesso

Gesso is primarily a mineral substance, and specific to the icon. It allows painting techniques that are impossible on canvas, paper or plaster and it plays an essential role since it reflects light through the colours and thereby ensures their transparency.

Preparation (15 minutes)

1 Re-heat the rabbit-skin glue. Gradually sprinkle in the whiting powder (calcium carbonate) without stirring it, until it is saturated. This should not take more than a quarter of an hour. Saturation takes place when the chalk forms a layer at the bottom of the jar and accumulates up to a few millimetres below the surface of the glue. If the chalk forms in the shape of a mountain, turn the jar slightly so that the chalk mountain collapses and then continue to add more chalk until it reaches the surface of the glue.

2 Now mix it gently with a stick or spoon until the mixture is homogenous – do not remove the utensil from the gesso while you mix because this will introduce unwanted air.

⚷ The consistency of the gesso should be similar to yoghurt. If it becomes thicker, add water to return it to fluidity.

Storing gesso

The gesso can be stored in the fridge for a few weeks if it is covered. If it shows the slightest sign of change in appearance or particularly if it begins to smell, get rid of it.

Applying the gesso

This should be done while the gesso is warm (60°C) and it should be applied in 12 layers. These can be applied at intervals if that is convenient for you, for example, once in the morning and once in the evening over several days. You can also apply coats one after the other, but do not apply more than 6 coats consecutively.

So as not to degrade the gesso by reheating it too many times, take out just as much as you need with a spoon and put it in the bain-marie in a smaller jar to heat it up.

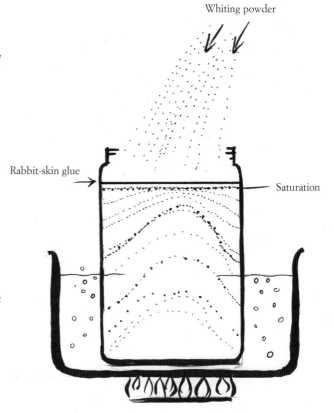

Gently heat the glue in a jar in a pan of boiling water. Now slowly sprinkle in the whiting until the whiting reaches just below the surface of the glue.

1 Cover the sides of the panel with warm gesso (see photograph 1). Next apply the gesso to the front of the panel. Vigorously dab the surface with the brush to encourage it to penetrate those parts of the glued fabric that have a tendency to resist (see photograph 2). Smooth the gesso by applying the brush lightly over the surface with horizontal strokes at a low angle (see photograph 3). Repeat, this time brushing with vertical strokes and a very light touch to leave minimal brush marks (see photograph 4, page 32).

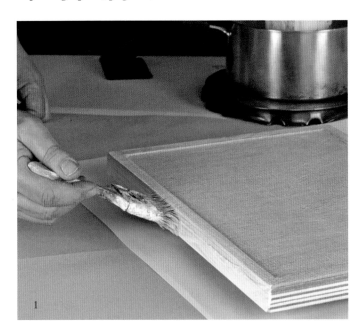

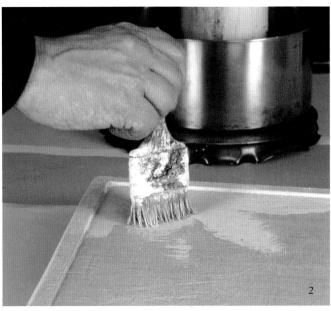

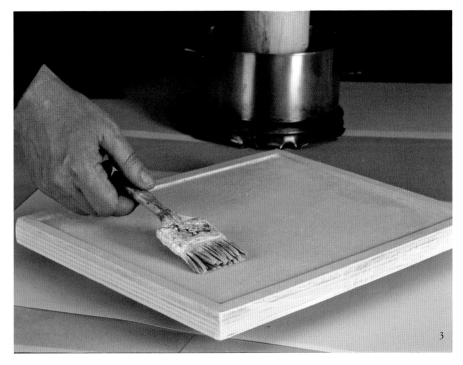

Top left: First, apply the gesso to the sides of the panel.

Top right: Next, apply the gesso to the front of the panel, dabbing it vigorously to ensure that it penetrates the fabric.

Left: Smooth over the gesso by lightly brushing with horizontal strokes.

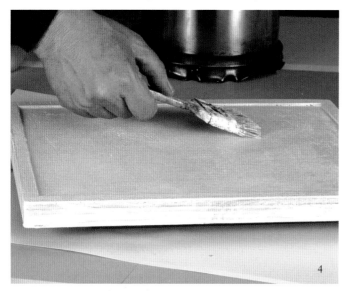

Once you have lightly brushed over the gesso with horizontal strokes, repeat the process with gentle vertical strokes, stopping if the gesso becomes tacky.

You will have just the amount of time necessary to carry out these three stages. As soon as the gesso begins to stick you must stop work. You can then choose between letting the gesso dry completely or putting on a second coat a few minutes after the first, depending on how much time you have available.

2 Apply the second coat in the same way as the first but without the vigorous dabbing, and reversing the direction of the brush strokes: apply the gesso, brush with vertical brush strokes then brush with horizontal brush strokes. This process of reversing the brush strokes should be followed for all remaining coats. After about fifteen minutes, you can apply the next layer.

3 Repeat the process from step 2, but brush more gently and remember to reverse the direction of the brush strokes: apply the gesso, brush with horizontal brush strokes then brush with vertical brush strokes.

4 Apply the fourth coat in the same way as the third, but this time smooth over the surface with your hand (see photograph 5). Once the layer has begun to adhere, touch it with your fingertips, and when you find it is no longer sticky but still soft, massage the surface. Spit on to the panel – you can wet the ends of your fingers with water, if you prefer, but saliva is much more effective – and then make very gentle circular movements with your fingertips, without damaging the layer of gesso. This process will remove some of the traces of the brush and will make sanding much easier.

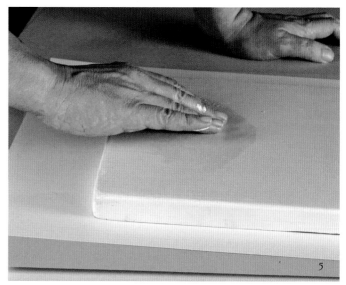

Having applied the fourth layer of gesso, once it is no longer sticky, you can begin to massage the surface with your fingers: spit on the surface and then massage it gently.

☞ If you accidentally mess up the fresh layers of gesso, allow the surface to dry and then sand it with 80-grit sandpaper. Fill any dips or hollows with a few drops of tepid gesso, spreading the thick gesso with a spatula or a ruler as if you were plastering a wall. Repeat the process if necessary. Once dry, sand this layer before applying the next coat.

5 Apply the fifth coat, reversing the direction of the brush strokes, and from now on, after each layer, gently massage the surface with your fingertips (see photograph 5).

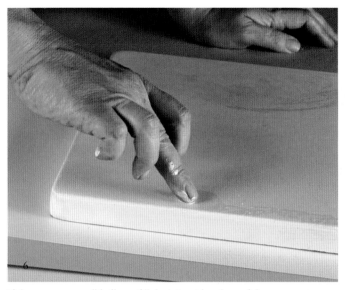

If there are any small hollows, fill them in with a drop of the gesso, spreading it out with your fingers.

6 Apply the sixth layer, reversing the direction of the brush strokes. It sometimes helps to add 5 drops of linseed oil to the gesso.

7 Apply the seventh layer in the same way, but you can now try smoothing the surface with the palm of your hand. If there are any small hollows, fill them in with a drop of the gesso, spreading it out with your fingers (see photograph 6).

8 Apply the eighth layer, making sure the gesso retains its fluidity. Smooth the surface with your whole hand.

9 Apply the ninth, tenth, eleventh and twelfth layers in the same way. By the end of the process, the surface should be as smooth and hard as you can make it. Leave the gesso to dry completely.

Sanding

This is the most physical stage in icon creation. Use a sanding block, which can be just a simple block of wood that is comfortable in your hand. You will need waterproof sandpaper in grits of 80, 200, 500, 800 and 1000 or similar.

1 We will start with 80-grit sandpaper, but first of all inspect your panel under a good light. It should look similar to the panel shown in photograph 7.

The finished panel should be as smooth and hard as ivory.

2 Sand with 80-grit sandpaper in a circular motion to smooth out all the peaks. It is possible to sand dry or wet. Dry sanding has the advantage of immediacy but the inconvenience of creating a lot of dust; with wet sanding, the sandpaper is wetted with water and should be washed regularly. To check the surface of the panel, wipe a sponge over it frequently. Using either method, monitor your progress under good light. Sand the surface until all the peaks and holes have gone (if there are significant holes, you may need to fill them in) before moving on to finer-grain sandpaper.

3 Now start sanding with 200-grit sandpaper to remove the scratches left by the 80-grit paper. Work you way through the remaining grades of sandpaper: the 500 grit removes the scratches of the 200 grit, the 800 grit removes those of the 500 grit and the 1000-grit sandpaper polishes the surface like ivory. You have finished the first stage – well done! On this hard white surface, now as smooth as baby's skin, a new adventure is about to start.

Use progressively finer and finer sandpaper to achieve the smoothest surface possible.

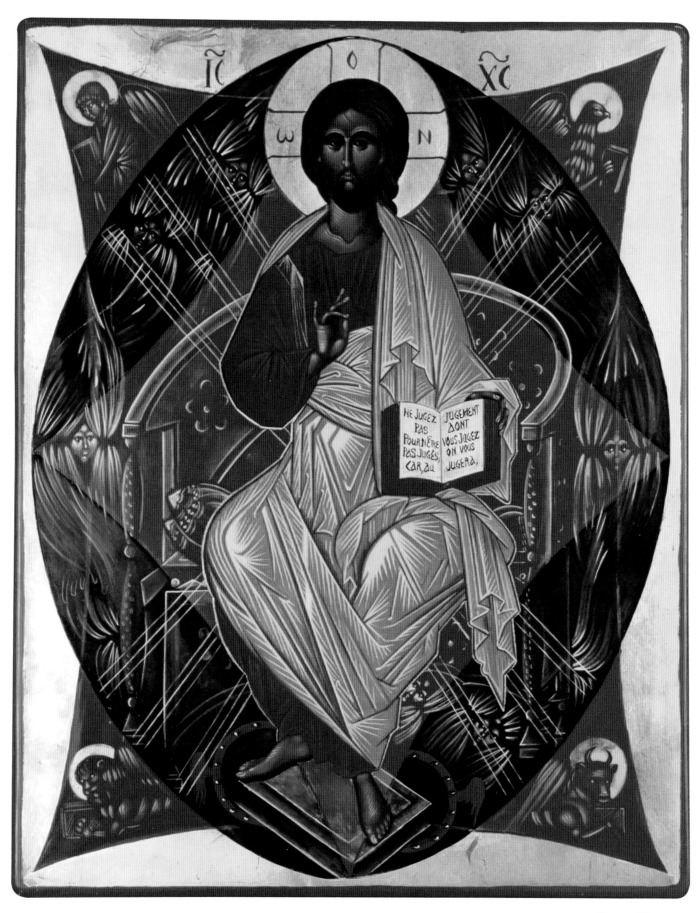

Christ in Glory.

5 Byzantine Drawing

'Drawing is fundamental; it gives life to the dormant energies inside ourselves and helps us find the life-force.' (Geneviève Gouverneur, iconographer)

The Byzantine style

The Byzantine style was born from unprecedented formal developments. Its main focus is the spiritualisation of shapes and subjects – the inner life of elements in the composition is more important than physical appearance.

Byzantine drawing is not an imitation of the real. It is an interior representation, which unites observation and knowledge and reveals the meaning of the whole. The main construction lines subdivide the picture space to create a sense of harmony. The compositional elements – the vertical line, the circle, the diagonal line, symmetry and proportion – symbolise the divine and the relationship between God and man. Straight lines and curves create directions, rhythms and rhyme; they answer and balance each other. But the drawing of an icon is not just about defining its forms and marking out shapes – it has its own life, each stroke bringing energy to the elements depicted and animating the composition as a whole. The refined shapes embody the message within the whole. In this way the subject is brought to life by thought, through the drawing.

Drawing of the eagle of St John.

Byzantine drawing uses simple, extended lines, animated by contained modulations that suggest movement. The iconographer's touch is present and visible; it brings out the essential nature of the shape. With this effort of simplification, the gesture goes beyond description of material realities to resemble the intention. This style of drawing is highly stylised, simple yet bold; it is close to symbolism. Animated both by dynamic motion and a serene and perpetual fullness, the drawing evokes eternity in an instant.

Geometry

Geometry, the measuring of the Earth and its objects, brings spirit and matter, meaning and shape into a dialogue. It is this relationship that determines the proportions of the panel and the structure of each composition, and it presides over the canon of proportions relating to the human body in icon painting.

Even within the strict geometrical rules of icon painting there is room to play, especially with placements at the edges.

Composition is structured around the interior lines of the rectangle but it avoids rigidity by toying with these borders. The drawings on this page include their geometrical construction lines, showing the precise and careful geometry utilised in icon painting.

The geometrical structure creates a sense of harmony in the composition.

The composition of standing figures makes use of three squares stacked on top of each other.

The human body

In Byzantine drawing, the human body is portrayed in complete contrast to the athletic ideals of antiquity. It is relatively static. While chests and feet are powerful, arms are thin and legs are elongated, hands are large and fingers are outsized; faces are stretched down to narrow noses, small mouths are sometimes crinkled with austere wrinkles, eyes are outlined and hair of all types flows serenely. Figures are portrayed with open expressions, detached from passions, and viewers may feel themselves observed. Figural proportions vary according to region and date of production. For example, the height of figures ranges from 5 to 13 times the height of the head. When all heads and bodies are portrayed in an almost identical manner, this is perhaps a symbolic depiction of the communion of the saints, and differentiation is achieved through the details.

Head The head is made up of three concentric circles. The first is centred on the bridge of the nose, between the eyes, with the length of the nose forming the radius of the circle. The length of the nose is used as the unit of measurement for the face and the body as a whole. The second circle, of double the radius, contains the head, while the largest circle contains the halo. The circle, universally recognised as a symbol of heaven and eternity, reigns internally over the harmony of figures, revealing the presence of the divine in man.

In time you will see that rather than being restrictive, the iconographic rules are the way markers for your journey.

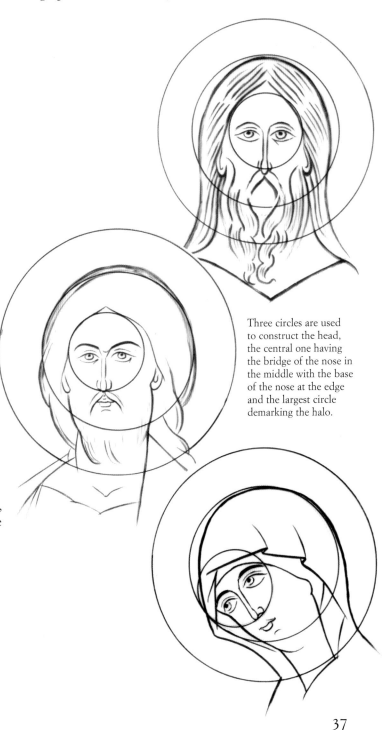

Three circles are used to construct the head, the central one having the bridge of the nose in the middle with the base of the nose at the edge and the largest circle demarking the halo.

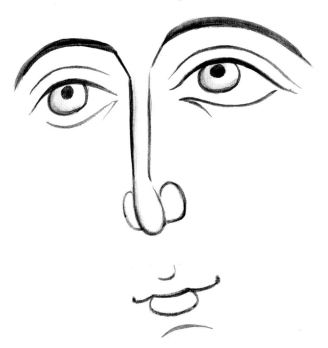

The drawing of facial features follows a few simple rules to create open, contemplative faces.

Eyes The lines of the eyelids do not meet; the upper eyelid is more arched and substantial. The iris is oval, at a slight tangent, and its line is not broken by that of the upper eyelid, as it would be in real life. The pupil is also at a tangent to the line of the eyelashes. There is less than the width of an eye between the two eyes, bringing the eyes closer together than in reality.

Nose The nose is made up of three shapes: the tip, which has a flared, receptive shape; the top of the nose, which is narrow and tapering, sometimes curved, and the end of the nose, which should be rounded like a seed and turned somewhat inwards.

Mouth Just larger than the nostrils, the mouth is drawn as three waves. The line of the upper lip is not demarcated – it will emerge with subsequent highlights.

37

Clothes

Clothes show their inheritance from antiquity, and the folds in the fabric are used to express the interior life of the figures represented. Fabric is more or less stylised depending on the region and date of production. The folds are sometimes geometrical to take on the appearance of crystal but never lose the illusion of the texture of fabric. The armour of military saints, the clothes of the Byzantine court of angels and ecclesiastical clothes all lend themselves to vibrant and musical ornamentation, rich with meaning.

Perspective

By rejecting a single viewpoint, perspective in Byzantine art privileges the meaning of shapes; by suppressing the depth of the image it offers an immediate experience of the presence of figures.

Using a juxtaposition of several systems of perspective and composition – isometric perspective, inverted perspective, conical perspective, perspective of importance, over-running the frame – figures, landscapes, objects and architecture seem to advance towards the viewer. It is in this space, between the viewer and the image, that the icon plays its unique role. (Examples of some of these perspective systems are shown in the illustrations below.)

Grounding the subject

Although Byzantine art aims to 'dematerialise' the image, it remains faithful to the laws of gravity. Figures, buildings, objects and plants are firmly grounded, and emanate a sense of solidity and calm. Depictions of folds in clothing express the invisible but nonetheless conform to the laws of physics. Saints express their demeanour by the position of their heads, the stance of their backs and bodies, their interior weight.

The demeanours, gestures, clothing and facial expressions of the saints express their interior transformation and invite meditation. However, icons do not shy away from depictions of earthly suffering and compassion.

Inverted perspective: the lines leading towards the vanishing points converge towards the viewer instead of running away from him.

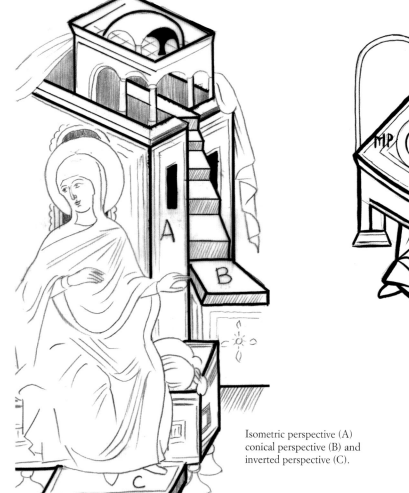

Isometric perspective (A) conical perspective (B) and inverted perspective (C).

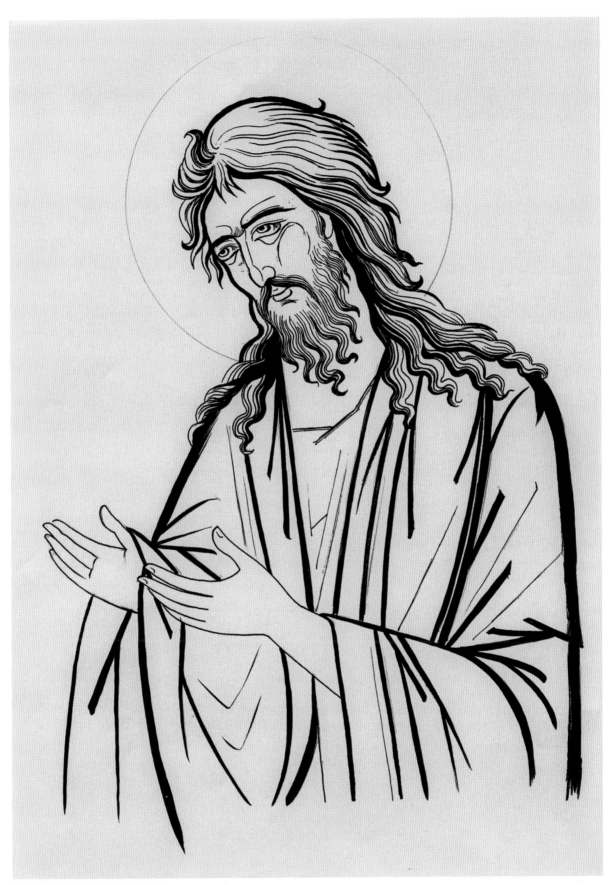

Saint John the Baptist, study after a Cretan icon of 1542.

Drawing on paper

Materials
- Drawing paper
- Ruler
- Compass
- HB technical pencil
- Rubber
- Pen
- Tracing paper
- Masking tape

Byzantine drawing is borne of a completely different intention to that which we are used to. The drawing is not trying to copy appearances or superficial beauty but is instead about the essence of the subject. All the different elements of the composition are positioned for balanced and harmony, and even the negative spaces (the gaps between objects) are invested with a formal significance. Since we have all been conditioned by post-medieval art, this style of drawing may seem rather formalised and rigid. In fact, it offers an alternative way of seeing that can be discovered only by observation and understood through practice, and which quickly becomes a joy. It is very important that the drawing passes through your hands and experiences the force which guides them, since it has much to offer, and in return it receives a great deal from you.

Construction lines: the key to a successful drawing
Proportion We can reproduce the icon we are working from at the same size or we can enlarge it, but the most important thing is to maintain its proportions. Measure the interior frame and then divide the height by the width: you should get 1.4. You should respect this proportion whatever size panel you are using. For example, if the inner panel is 24cm (9½in) wide, 24 × 1.4 = 33.6cm (13⅜in) which should be its height; if the inner panel is 60cm (23½in) high, 60 divided by 1.4 = 42.8cm (16¾in) and this should be its width.

The frame When considering what size of panel to use, do not forget the frame. If you are working from a photograph of the original, this may not be included in your reference photograph. Since the frame forms part of the panel, the more space you allocate to the frame, the smaller the image will be. The width of the frame varies depending on when it was painted and sometimes icons had no frames at all.

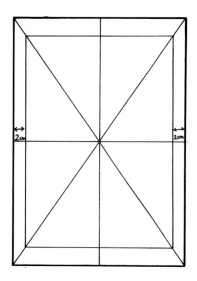

1

1 Whatever frame is required, it should be wider at the top and bottom than at the sides. Let us suppose you have a panel measuring 40 × 28.6cm (15¾ × 11¼in). With a pen, draw a rectangle of this size on a piece of drawing paper. Check your accuracy by drawing diagonal lines between the corners and measuring them – they should be the same length.

2 Supposing you want a frame 2cm (¾in) wide. Draw a line 2cm (¾in) inside the vertical sides of the rectangle. The width of the frame at the top and bottom is determined by the intersection with your diagonal lines. You now have an interior frame with the same proportions as the panel and the original. Now add the vertical and horizontal axes of the image by dividing the height and width of the interior frame in half (see diagram 1).

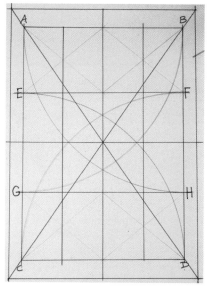

2

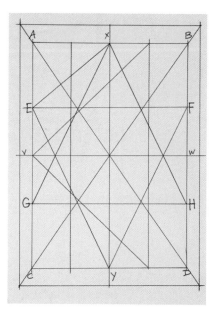

3

3 Set your compass to the width of the rectangle and draw a faint circle from each corner of the inner panel (excluding the frame). Draw two horizontal lines to join up the two sets of marks made where the circles intersect with the rectangle's length (E-F and G-H on diagram 2, page 40). This is called 'folding the short side on to the long side'.

4 Now refer to diagram 3, page 40 to add the diagonals of the construction lines. This grid will enable you to enlarge the drawing faithfully and to appreciate the relationship between the rectangle's frame and its content.

5 Make a copy of your original reference photograph and use a pen, ruler and set square to copy the same construction lines on to it (see the example below).

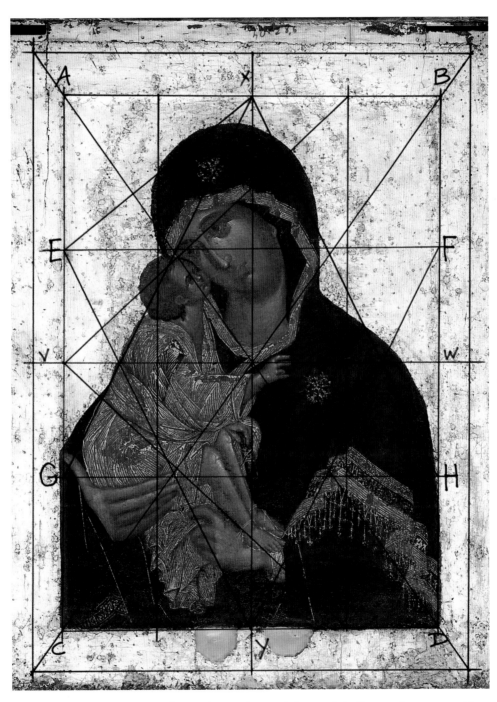

Draw construction lines on a copy of your reference photograph that match the lines you drew on paper. These will help with the accuracy of your drawing and deepen your understanding of the composition.

Sketching the composition

It is not always easy to read the composition of the original icon. The construction lines you have already drawn will help in this case.

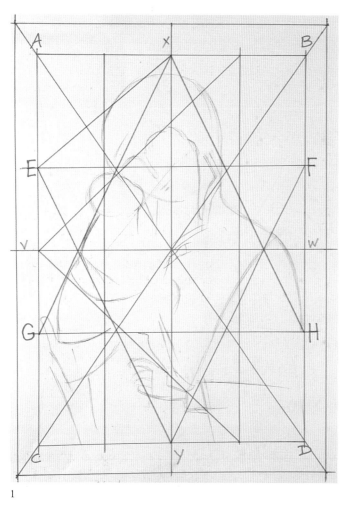

1

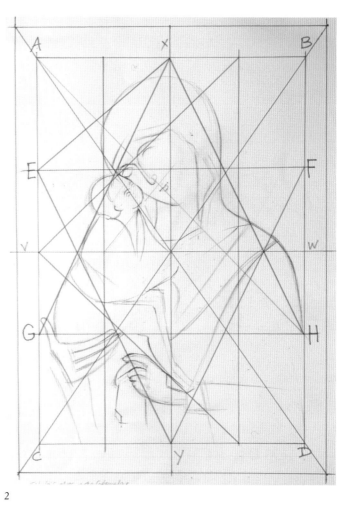

2

1 Sketch the main outlines of the figure with a technical pencil – you will need the light touch of a relaxed hand. Remember that you can add the details later so all you want at this stage are the general forms (see drawing 1). Try to focus on the composition as a whole, drawing the individual shapes in relation to each other and to the whole. In case of difficulty, it can help to put both the model and your copy upside down and work that way, since you will not be distracted by the representation. Do not hesitate to erase elements and correct the drawing as much as needed – it is important that it looks right and you will learn a great deal by correcting your work. Learn from your mistakes and practice will make perfect.

2 Begin to add more detail and firm up the contours (see drawing 2). The main shapes will gradually become better defined. You will be able to add the smaller shapes and finish with the facial features, but do not try to capture the expression. Certain elements should not be drawn – they will come out themselves when you apply the highlights.

3 Return now to the composition to define and strengthen the drawing further. There should be no blurry, uncertain lines or superfluous, wobbly lines; the drawing should exude strength, serenity and harmony. Draw the haloes by placing the tip of your compass on points O and M shown in drawing 3.

Transfer the drawing to the panel

The transfer of the drawing to the panel is done with a pencil, red chalk crayon and tracing paper. Be very careful not to lose the quality of the work in the sketch and try instead to improve on it.

1 Tape tracing paper over the drawing and trace over the lines with pencil. Mark out the corners of the frame and the extremities of the axes.

2 Turn over the tracing paper and go over all lines firmly with the red chalk pencil, which should be soft and dry.

3 Measure and mark the extremities of the axes with the red chalk pencil on the surface of the panel in order to position the tracing paper correctly on the panel before taping it down (three marks should be enough).

4 Tape the tracing over the gessoed panel, aligning the marks. Use a ballpoint pen to trace over the lines, pressing down hard. At intervals, lift up a corner of the tracing paper to make sure that you are getting a clean, fine red line.

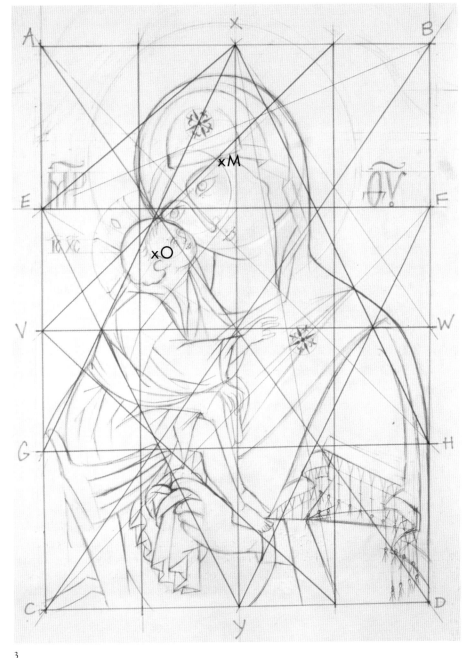

3

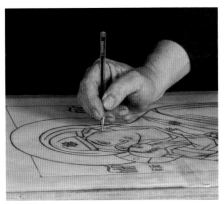

Use a ballpoint pen to transfer the tracing of the drawing to the prepared panel.

43

Drawing with a paintbrush

Materials
- 1 egg
- Water
- Cider or wine vinegar
- Watercolour palette or shells
- 3cl (1fl oz) and 9cl (3fl oz) dropper bottles
- Brush for mixing and crushing pigment, preferable a small hog-hair brush
- Sable brushes for painting
- Synthetic paintbrush for correcting mistakes

Preparing the egg binder (emulsion)

1 Take an ordinary egg and break it carefully into one hand, allowing the white to fall between your fingers but saving the yoke (see the photograph below). Roll it from one hand to the other to remove all the white. The remaining white will stick to your hands, so wash them one at a time so that the yolk is completely clean. (The slightest presence of egg white changes the properties of the emulsion.)

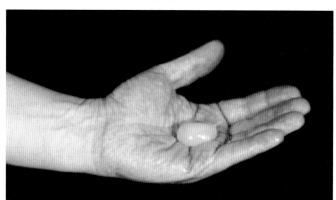

2 Pierce the yolk with the tip of a knife and pour the contents into a jar, keeping hold of the skin, which can then be thrown away. Add a dessertspoon of water and ¾ of a dessertspoon of cider or wine vinegar. Mix gently then pour the mixture into the 3cl (1fl oz) dropper bottle. This mix is the medium or binder, which we will refer to as the emulsion. It can be stored for up to three weeks in the fridge.

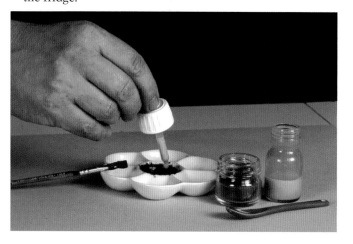

Mixing up the paint

1 Take the equivalent of half a teaspoon of burnt sienna pigment and put it in a well of the palette or in a shell. Add 4 drops of the emulsion. Crush the mixture together as you stir it with the small, stiff hog-bristle brush.

2 Add more emulsion, drop by drop, and pound the mixture until you obtain a shiny cream with a consistency halfway between liquid and solid.

⚷ This is an essential stage. It establishes the correct ratio of pigment and emulsion, which in turn determines the beauty of the colours and the solidity and therefore also the durability of the pictorial film. The paint should not be runny.

3 For drawing purposes, add up to 5cl (1¾fl oz) of water to the paint mixture according to the desired transparency.

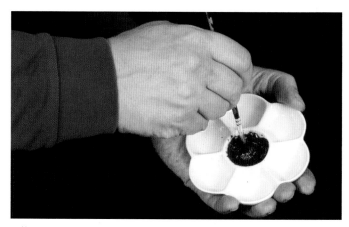

Allowing the pigment to settle

Settling of the pigment occurs once water is added. The pigment is made up of particles of different sizes. As the mixture settles, the larger elements fall faster and land at the bottom while the smaller ones remain in suspension in the liquid. For this reason, use the paint on the surface of the jar of pigment and not the paint from the bottom.

Left: Roll the yolk from hand to hand to remove the white, which will come off on your hands.

Below left: Add the egg emulsion to the pigment drop by drop.

Above: Pound the pigment and emulsion with a hog-hair brush until you obtain a glossy cream.

Practice exercises on paper

Before starting work on the panel, practise different brushstrokes with tempera on paper because the paint does not handle like other paints.

1 Dilute your paint by adding three or four drops of water to it. Mix it with the hog bristle brush and then allow it to settle for a few minutes.

2 Working on an ordinary piece of paper, dip a sable brush in the paint and make small strokes to familiarise yourself with its touch. Do this with all your sable brushes. Add one or two more drops of water, if necessary.

3 Practise writing your name in capitals, using increasingly smaller and finer downstrokes and upstrokes, as if using a pen. This will also be useful practice for adding the inscription later (see chapter 8).

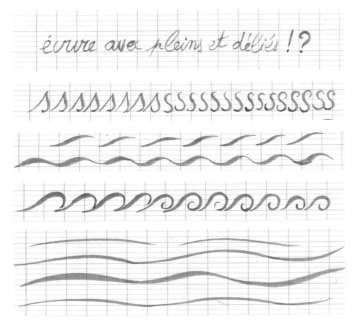

4 Practise using the brush in different ways – a line of Ss or waves, using a press and release technique, lines drawn lightly and hard. Try drawing large curves and straight lines using a single gesture made up of a number of small strokes.

5 To draw large curves you will need a pivot – your elbow or forearm will do. Position the piece of paper so your movement is free, sit comfortably and have your little finger slide over the surface. Do not press too hard on the tip of the paintbrush. If the paint thickens, add a drop of water.

6 Practise until you can relax your hand and master your movements. You will see that drawing with the paintbrush is easier and more enjoyable, and somehow more alive, than drawing with a pencil.

Brush care Egg tempera will dry in the bristles of the paintbrush and, once dry, it is pretty much impossible to remove. Wash the brush out vigorously in a glass of water but do not leave the brush to stand on its head because once damaged it is difficult to regain the pointiness of the tip.

45

Brush drawing on the panel

We will return now to the drawing of *Our Lady of the Don* and bring it to life. The quality of your drawing is vital. It is this that will support all further work. The movement of the brush adds feeling to the stroke; the downstrokes and upstrokes are the line's breath. The secret is perhaps simplicity and clarity. The technique is borne from a search for interior accuracy, a search in which thought, emotion and the human body are called together.

1 We will proceed slowly. At first, use a slightly diluted paint because this is easier to apply to the panel. Simply add a little water to your mixture as you did when working on paper (see pages 44–45). Start with the contour of the Virgin's cloak, using a light touch. You can turn the panel on its side to make your movement easier. Work over the red chalk lines, referring to the pointers below.

2 So that the drawing does not disappear beneath the layers of colour that will be applied above it, go over all the lines (except the frame) with a thicker, more opaque paint. To do this, prepare burnt sienna once again (with the emulsion, of course) using just enough water to be able to paint the lines. The brushstrokes should be thinner and more accurate than when you painted the contours the first time but there is still time to make corrections.

Pointers for good brush drawing

- The eraser paintbrush can be of great help to soften a line (see photograph 1). Always keep it wet and note that it works best when it is used immediately.
- The drawing should be free and forceful – it is the drawing that gives the icon its strength and it should never be sentimental. Your hand movement is very important. It relies upon a good body position. You must sit comfortably with a good posture so that you can release and relax your hand a little. Do not focus you gaze too intently. Instead, take in the movement and all that it encompasses. Try to work in a relaxed, confident manner.

Use your other hand to support the working hand.

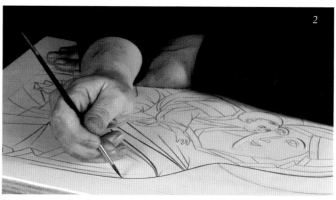
When working on the edge of the panel, a book can provide useful support for your hand.

Use the finest brushstrokes on the faces.

- Lines should be fluid and the end of a stroke should either be thin or square.
- You can use your other hand to support your drawing arm and to raise it to the level of the panel or use it as a pivot (see photograph 2).
- To draw on areas near the edge of the panel, when your hand cannot rest on the surface, rest it on a piece of wood or a book of the same thickness (see photograph 3).
- Use fine lines for delicate areas such as the features of the faces (see photograph 4).

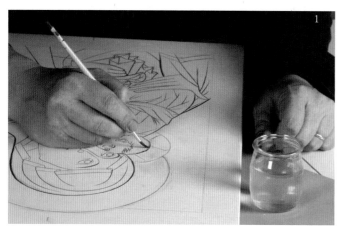
Soften mistakes or hard lines with the eraser paintbrush.

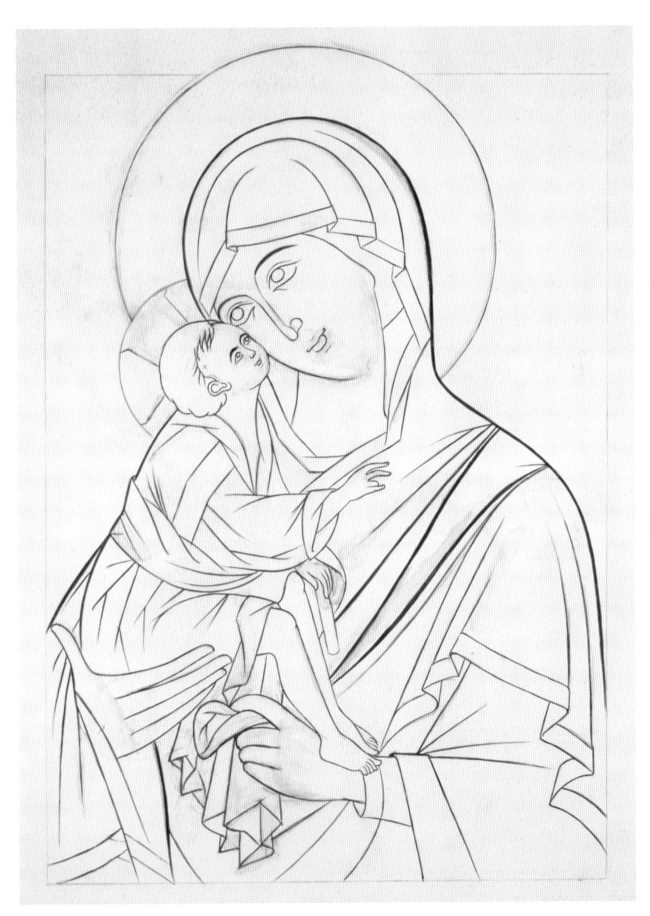

The finished drawing.

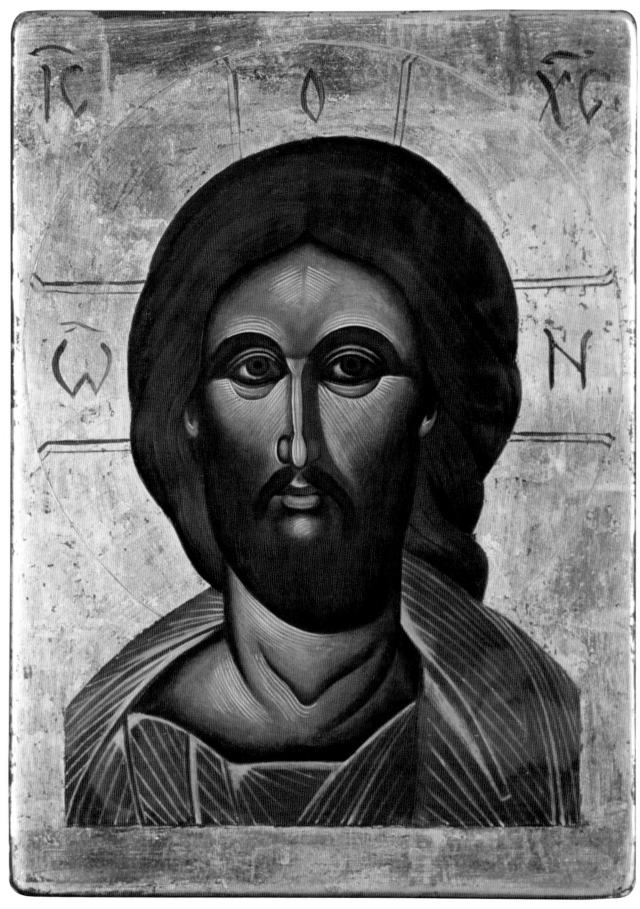

The Saviour.

6 Gold

Gold is essential. It symbolises the divine and uncreated light, and it illuminates the background of icons, the haloes of saints, clothing and certain objects. Its remarkable strength affects the colours of faces, clothes, buildings and natural elements. In effect, the colours have to hold up in front of its brightness.

Although the gold is now lost from *Our Lady of the Don*, we will apply some to the haloes on our icon. There are two methods for applying gold. The first method, using oil-based size, is the easiest, while water gilding (see page 51) is a lot more difficult but also the most beautiful when done correctly.

Note: sometimes gold leaf is replaced with gold paint, white or even red or green paint.

Applying gold with oil-based size

Making and applying gilder's bole
Gilder's bole is composed of our rabbit-skin base glue (see page 28) and Armenian bole, which is a very fine clay. Mix it up as follows:

1 Measure one part of base glue (rabbit-skin glue) into a jar and then add half a part of Armenian bole and three parts of water. Heat the jar in a bain-marie, patiently stirring it, then strain it through a pair of tights and let it settle.

2 When the liquid is tepid, apply it to the areas of the panel you want to gild (see photograph 1, below). Apply three coats in total, rubbing the surface with 1000-grit sandpaper once each coat is dry. The beauty of the final result depends on the quality of the bole. Far from hiding its imperfections, the gold will reveal them – that is the role of light.

Materials
- Rabbit-skin glue
- Armenian bole in paste form
- Sandpaper
- Paintbrushes
- Gilding size or varnish
- Scissors
- Sized gold leaf

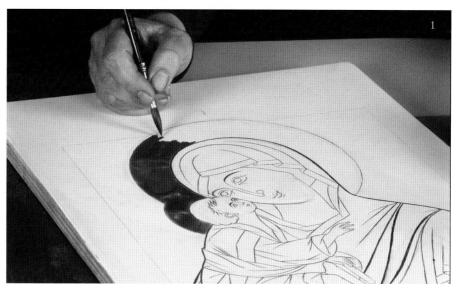

Paint the prepared bole over the area to be gilded while it is still tepid.

Applying the size

Size is a kind of varnish, and it is applied over the bole. The gold leaf will be applied on top as soon as the size is ready – it should no longer be sticky but it will 'squeak' slightly to the touch. This can take 3, 6 or 12 hours depending on the gilder's size used, and around 2 hours for quick-dry size.

To apply the size, first wipe any dust from the sanded bole and then apply a very thin layer of size, by 'pulling' the liquid across the surface with the brush (see photograph 2).

Adding the gold leaf

Sized gold leaf is available in booklets and comes in different qualities and colours. Be careful not to touch the gold when you apply it to the surface because not only can it can stick to your fingers but you may also tarnish it.

Top: Once the bole has dried and been sanded and wiped clean, paint the size over the bole.

Above: Trim the three narrow margins of paper around each sheet of gold leaf, holding it by the wider margin.

1 Choose a booklet and count the number of leaves. Trim the three narrow margins of paper from around each sheet of gold leaf, holding it by the wider margin (see photograph 3). The paper must not come into contact with the size or your fingers.

2 Once the size is ready, apply the leaves: lay them down one by one, overlapping them, and pulling away the paper as you go. Press gently on the paper with your fingers (see photograph 4). Keep the off-cuts because they will be useful for filling in any gaps in the gilding.

3 Once the size has dried, brush away the excess gold using a soft paintbrush (see photograph 5). Put a very small amount of size on the gaps and fill them with the gold off-cuts.

4 I recommend that you paint over the gold with shellac to seal it and prevent tarnishing.

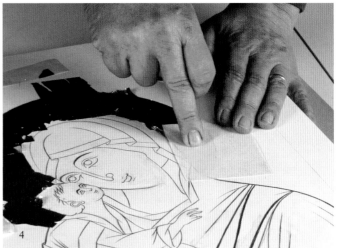

Top: Press the leaf down by rubbing over the paper from the gold leaf – do not touch the leaf with your fingers directly.

Above: Once you are sure the size is dry, rub off the excess gold with a soft brush.

Applying gold leaf using water gilding

Materials
- Booklet of loose gold leaf
- Gilder's cushion
- Gilder's knife
- Gilder's tip
- Agate burnisher
- Squirrel-hair tamping brush for applying the gold and for sweeping up excess gold leaf
- Second squirrel-hair water-gilding brush to moisten the surface
- 90% alcohol
- Shellac

1 Prepare the gilder's bole and apply five coats to the area(s) to be gilded as described on page 49. Rub over the surface with a rough piece of fabric until it shines.

2 In a glass jar, mix 7 parts of water to 3 parts of 90% alcohol plus a few drops of bole glue. This is your size.

3 Hold the booklet of loose gold-leaf sheets above the gilder's cushion and with a gilder's knife, let one slide out. Smooth down the sheet on the cushion by blowing lightly on to it from directly above.

4 Use the gilder's knife to cut the sheet of gold into squares the same size as the area to be gilded. Place the knife blade on the gold leaf and make a small back and forth movement as you press down and then raise the knife.

5 Rest the panel at a slight angle. Generously moisten a small part of the area to be gilded with water size as if you were applying a wash with a watercolour brush. Take a piece of gold with the gilder's tip and lay it on to the wetted area. To make the piece of gold stick to the tip, slightly rub it on your cheek or on the back of your hand to create static electricity that will attract the gold. Once the gold has been laid down, it will extend itself over the bole. Press down lightly with a soft brush and overlap the pieces of gold.

6 The gilded area can be polished with a burnisher once it has been left to dry for two hours, and for a few hours after that. Press down lightly with the agate burnisher and make small circular movements.

7 Once you have finished burnishing, clean the surface with a soft paintbrush.

8 If any gaps remain in the gold, apply more water size to the area where gold is missing. With the panel flat, apply gold, using larger pieces than the moistened area. Wait an hour and burnish once again. Continue until there are no more gaps.

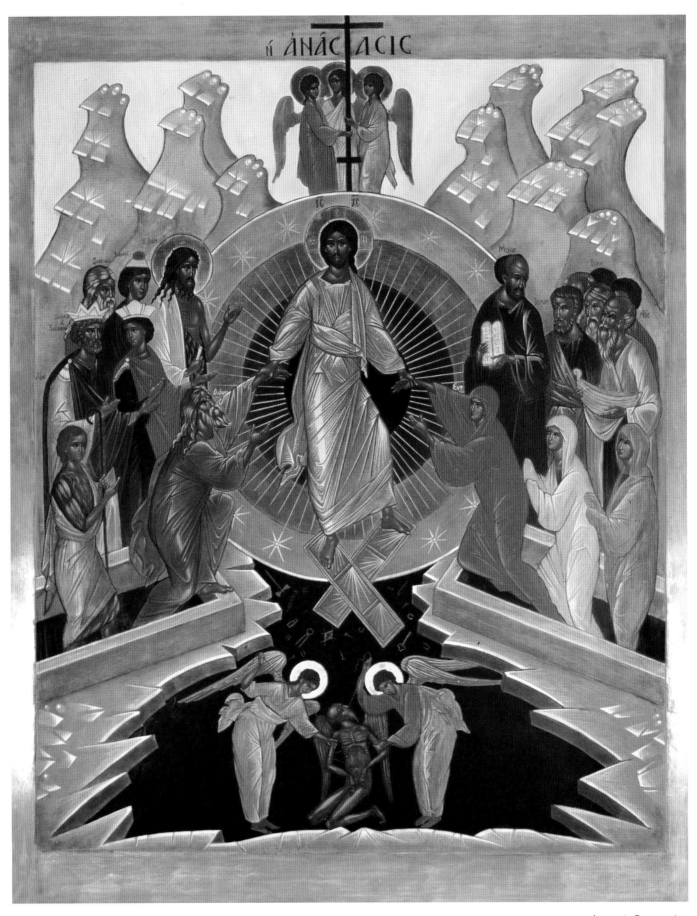

ή ΑΝΑCΤΑCIC

Anastasis, Resurrection.

7 Colour and light

Henri Matisse first saw icons and frescoes during a visit to Moscow in 1911, and declared: 'The Russians have no doubts about the ancient treasure in their possession... French painters should come to study in Russia. Italy has less to offer in this respect...'

When Russian iconographers discovered the original colours of medieval icons, which were cleaned at the beginning of the twentieth century, they felt that the beauty of the colours was beyond them. This beauty can elevate us. It seems that ancient iconographers understood complementary colours and the effect that in the 19th century Chevreul called 'simultaneous contrast', which is a means of emphasising the brightness of complementary colours through juxtaposition. This technique can create loud as well as subtle harmonies, often bold and powerful, never acidic or aggressive as can sometimes be seen nowadays, no doubt due to the habit of printers in exaggerating the colours slightly and especially due to the use of poor photocopies.

A radiance of colour

The icon is a source of spiritual energy, its colours act directly on our souls. Icons bear witness to the knowledge of ancient iconographers who understood the effect of colours; the highly developed sense of harmony they created was born from their spirituality and it is this which we attempt to imitate. Is it not this radiance that mysteriously attracts us even when we are far from faith? 'And in truth this is the reawakening of the Joyful News in the depths of our being, the memory, forgotten but secretly harboured in its spiritual homeland. And since this revelation is received from He who has entered this spiritual homeland, we do not approach it from the outside, but inside ourselves we remember: the icon reminds us of the heavenly archetype.' (Father Paul Florensky)

The colours in icons are inspired by the sky, flowers and precious stones; in counterpoint to the steadfastness of the drawing they are joyful and fresh. The harmonies seem to sing of another life.

Notice that not all the colours in an icon will have the same intensity. Often one or two pure colours are dominant and the others are split up across the image, washed out or darkened. Very often, colours are repeated throughout an icon. If we look at our model, for example, the yellow-orange and gold of the Infant's robe is found again on the edge of His mother's cloak, whose headdress and robe are the same blue as His clavus (the stripe decorating His tunic). Areas of colour rhyme and bring rhythm and unity to the composition.

Traditional use of colour

Tradition attributes certain colours to the clothes of each saint, although there is an infinite range of purples or greens. This is where the iconographer's art comes into its own: in the choice of tints, their interplay and in the way colours rise from darker to lighter tones.

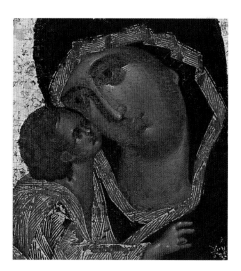

Here is a list of the traditional colours and their uses:
- White is for the Infant, for the Christ of the Transfiguration, for the Descent into Hell and for the angels.
- Purple is for the clothes of the Virgin and for Christ.
- Saffron-orange is for the Christ with St Peter and St Elie.
- Blue is for the clothes of Christ, for the Virgin, St John the Evangelist and the Baptist.
- Red is for Eve, St Anne, St Michael, St George and all the martyrs.
- Green is for St John the Evangelist and for a large number of saints.
- Red, green, yellow or brown ochres are omnipresent.
- Black is the colour of the abyss.
- Gold, sometimes replaced with yellow, green or red, is present in the background of icons, in the haloes and on fine hatching on the clothes.

The iconographer's palette

We can make our selection from the following pigments. Within each colour group, they are presented in order of opacity, from opaque to transparent. The most useful pigments are in bold text and essential pigments are underlined.

Earth colours

These are the same tones that were used by ancient iconographers and our method is faithful to theirs. These are the pigments we will use the most. Humble by their very nature, when transparent they are sublime. They are safe to use, reliable and durable. They should be left to settle.

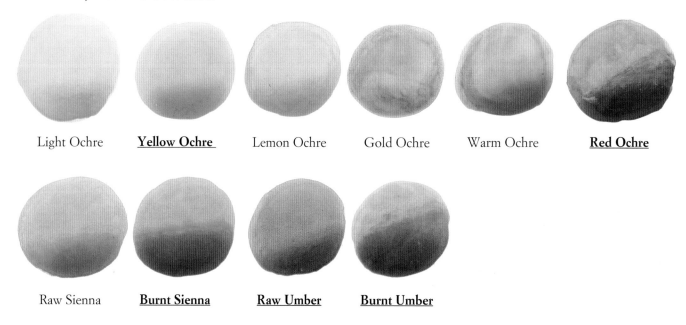

| Light Ochre | **Yellow Ochre** | Lemon Ochre | Gold Ochre | Warm Ochre | **Red Ochre** |

| Raw Sienna | **Burnt Sienna** | **Raw Umber** | **Burnt Umber** |

Green earth

There are a great many variants of green earth, which have different tones of green, yellow, brown or blue.

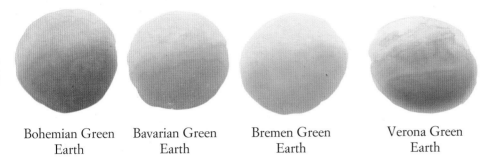

Bohemian Green Earth

Bavarian Green Earth

Bremen Green Earth

Verona Green Earth

Oxides

Obtained from iron (Mars colours) and other metals, these pigments are stronger than the earths.

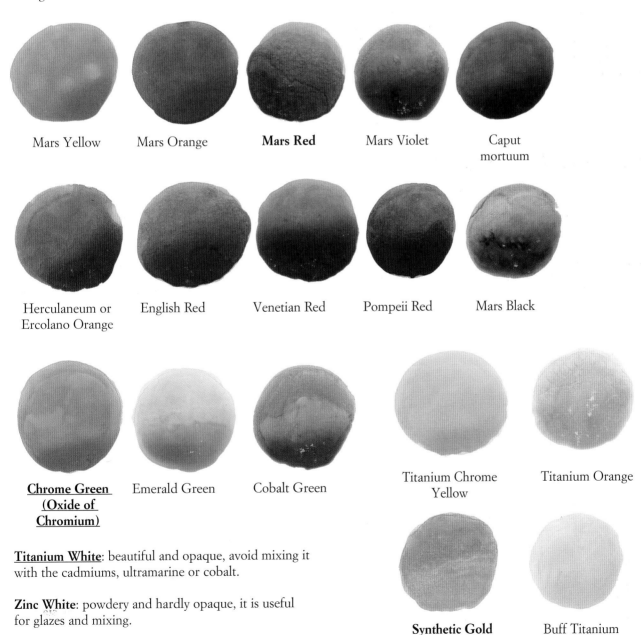

Mars Yellow

Mars Orange

Mars Red

Mars Violet

Caput mortuum

Herculaneum or Ercolano Orange

English Red

Venetian Red

Pompeii Red

Mars Black

<u>Chrome Green (Oxide of Chromium)</u>

Emerald Green

Cobalt Green

Titanium Chrome Yellow

Titanium Orange

Synthetic Gold

Buff Titanium

<u>Titanium White</u>: beautiful and opaque, avoid mixing it with the cadmiums, ultramarine or cobalt.

<u>Zinc White</u>: powdery and hardly opaque, it is useful for glazes and mixing.

Cadmiums

These are very intense pigments and are poisonous. Avoid mixing them with lead white, titanium white or ultramarine blue.

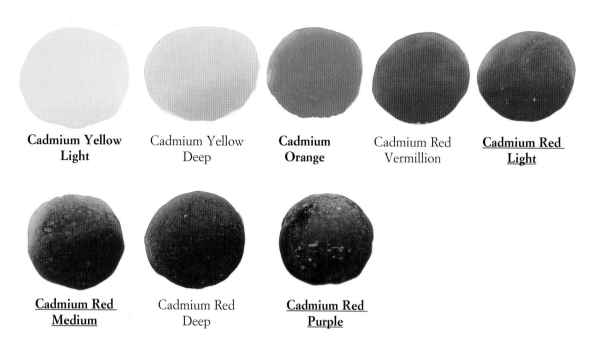

Cadmium Yellow Light	Cadmium Yellow Deep	**Cadmium Orange**	Cadmium Red Vermillion	**Cadmium Red Light**

Cadmium Red Medium	Cadmium Red Deep	**Cadmium Red Purple**

Lead-based pigments ☠

Lead White: the white used by Ancient iconographers. Treat this pigment with particular care.

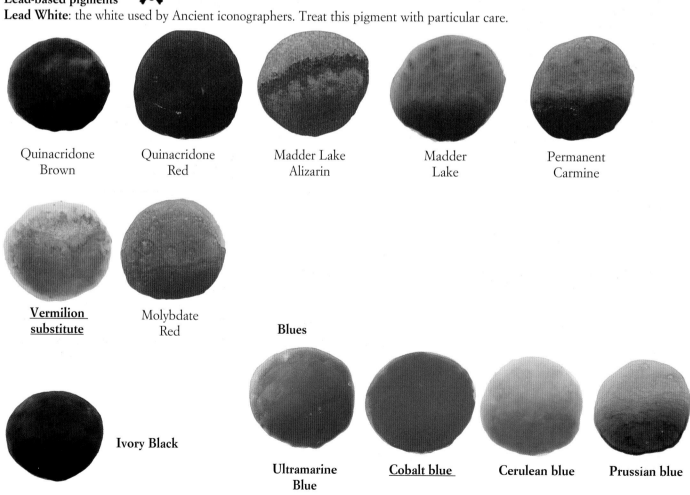

Quinacridone Brown	Quinacridone Red	Madder Lake Alizarin	Madder Lake	Permanent Carmine

Vermilion substitute	Molybdate Red

Blues

Ivory Black

Ultramarine Blue	**Cobalt blue**	Cerulean blue	Prussian blue

Opening the icon

To open the icon means to apply the first layers of paint to the panel. These are extremely pale washes.

> **Materials**
> - Hog-bristle brush
> - Containers such as shells or small jars or dishes
> - Palette
> - Emulsion (see page 44)
> - Water
> - Dropper bottles
> - Pigments and measuring spoons
> - Paintbrushes

We will start with the flesh tones.

1 Mix together half a teaspoon of yellow ochre with an equal quantity of raw umber. In a jar, dish or shell, mix half a teaspoon of pigment with a few drops of emulsion. Mix vigorously until the liquid has a creamy (but not runny) consistency. ☞⚷ It is important to get this right in order to ensure the integrity of the paint.

In a glass jar, vigorously mix the pigment with a few drops of emulsion until it is smooth and creamy.

2 Now dilute the paint to create a wash: add water and mix thoroughly.

Add water to the emulsion and mix thoroughly.

3 Allow the paint to settle. This takes about 10 minutes, but each pigment solution will require a different length of time to settle. Once it has settled completely, dabble your brush on the surface of the water to bring the smallest particles to the surface. Use only this top level of paint.

Leave the diluted paint to stand in order to separate out the sediment.

4 Decant the coloured liquid by pouring it slowly into another container or take out what you need with a pipette, leaving the sediment behind.

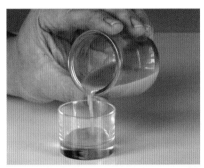

If you have mixed up a lot of paint, slowly pour it into another container, leaving the sediment behind.

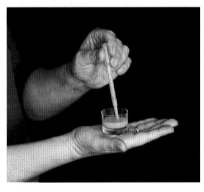

If you have mixed a small amount of paint, use a pipette to take off the liquid, leaving the sediment behind.

5 Test the colour by using a pipette to release a drop of colour on to some paper. The colour should not contain deposit and it should be very pale. You can add more water, if necessary.

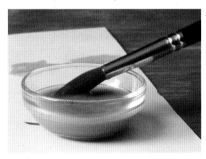

Test the colour on paper. If necessary, add more water.

The little-lake method

This icon painting method is called the 'little-lake method' or 'le petit lac' (see also the dry-brush method on page 81). The technique involves painting a large area with a transparent wash as uniformly as possible. This is achieved by creating a little pool or lake of paint at one end of an area to be coloured and then enlarging the pool across the surface area by adding more paint, little by little. The idea is not to brush the paint on, as you do in, say, watercolour, but to use the brush simply to place the paint on the panel – what matters is not the brush but the drop of colour on the tip. The brush tip should hardly touch the panel. This method covers the area to be painted quite quickly and, when dry, leaves a subtle mottled texture.

To apply the colour, first stir up the wash a little and then fill your paintbrush with the colour. Apply the first drop to the edge of the area you are going to paint and create a little lake on the paper or panel. Continue onwards, little by little, using short and fairly rapid sideways strokes to apply more paint and extend the lake over the whole section.

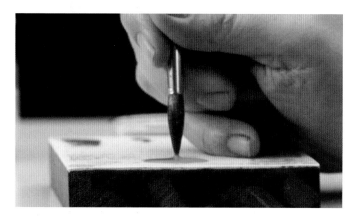

Pointers for using the little-lake method

* Do not pause – you have to keep your paintbrush full of paint and avoid leaving any gaps, as you cannot go back.
* Make sure you take the paint right up to the edges of the area and do not leave any white spaces.
* Feel free to rotate the panel in any way that makes it easier to work.
* If dust or a hair gets on to the paint, do not be tempted to remove it straight away. Allow the paint to dry and remove it later.

Starting with the shadows

The shadows are the base colours, dark but translucent, on to which we will gradually apply lighter and lighter tones. These shadowy base colours represent chaos or protoplasm, the primordial energy of the universe or essence of physical life.

Starting the flesh tones

1 Make a mix of yellow ochre and raw umber, as described on page 57, allowing the mixture to settle completely before decanting it. Test the colour on paper, and be sure that there are no large particles.

2 Now use this mix to paint the faces, hair and hands, taking the paint right over the lines of the drawing to cover them up. Use the little-lake method to work these areas section by section, from one end to the other. Keep returning to it so that the paint has no time to dry and leave a residue.

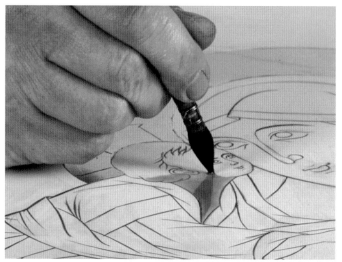

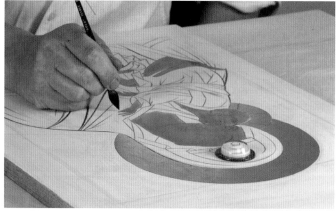

Once the paint has paled, refill your paintbrush and return immediately to the lake, never to the side. Do not tap or press down with the brush – this is not watercolour painting. The idea is to place the paint on the panel and leave it there: the paintbrush only rests and leaves its paint; its tip should not bend. Your touch should be light and parallel to the panel.

Painting the frame

1 Prepare a yellow ochre or gold ochre wash with a lot of water.

2 To avoid creating a line or tidemark where the painting for the frame begins and ends, it is a good idea to 'fade' the paint where you start and finish painting the frame. To do this, you will need a second paintbrush, which you should load with water. Apply the paint at your starting point and fade it by putting your wetted paintbrush inside the lake and pushing it forwards. The water and paint will mix together. Start the lake using a paintbrush loaded with water, which will help it to blend. Do not take the paint right up to the very edge of the panel or the pool will run on to the table.

3 Once you have painted the whole frame, fade the edge of the wet paint up to the edges of the panel.

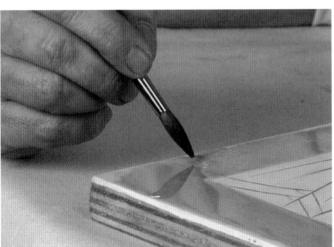

Drying

A small lake with a large surface area could take more than 4 hours to dry, but you should wait even longer before applying another coat – it is best to wait until the following day. To check whether a surface is dry, bring it to your lips. If it is cold, it is still wet. Do not attempt to speed up the drying process using a radiator or hairdryer, for example, as these can be disastrous.

Continue painting the base colours as follows:

The background should be painted the same colour as the frame, using the small bridge to prevent your arm touching the panel (see page 19). Once dry, apply a second layer of paint as light as the first to the background and to the frame.

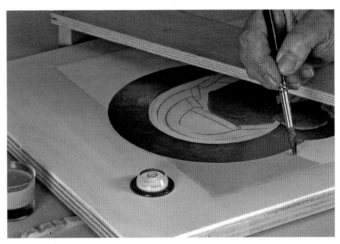

The blue is mixed from a wash containing half a teaspoon of cobalt blue, a little emulsion (see page 57) and a little less water than was needed for the base flesh tone (protoplasm). Allow it to settle and then decant it. Once the flesh tone is dry, paint all the blue surfaces: the cap, the fold, the sleeve and the clavus.

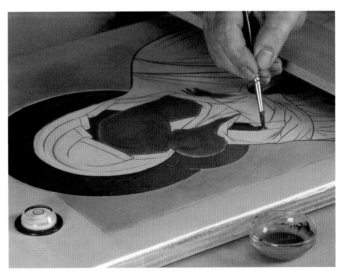

The cloak is painted in Mars red. Mix a wash of Mars red, allow it to settle then decant it. When the blue is dry enough, paint the Virgin's cloak.

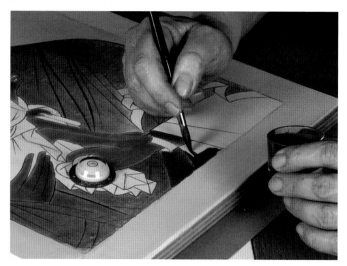

The Infant's clothing is coloured using a warm orange made by combining a third of a teaspoon of yellow ochre with a knife tip of red ochre. Leave it to settle properly, decant it and then paint the Infant's cloak and the trimmings on the Virgin's clothing.

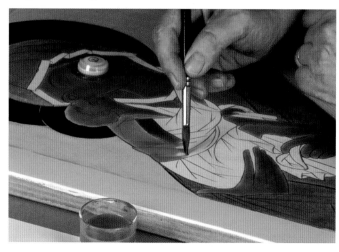

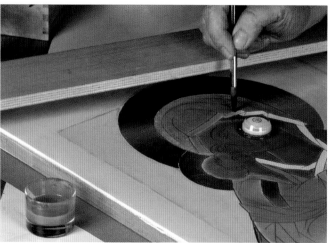

Now that all surfaces have been covered with the shadows, go over the drawing of the Virgin's cloak in black. Next, apply a second and then a third coat of paint to each area, ensuring that the following key points are adhered to:

- The background and the border should very light.
- The protoplasm (skin tone) should be a bit darker than Christ's clothing, but lighter than the Virgin's clothing.
- The lines of the drawing should still show through.
- The paint should be matt but not dull.

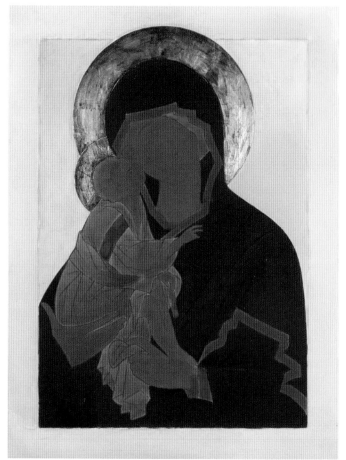

Degreasing

If the paint surface is shiny or greasy to the touch, you are using too much emulsion in your paint mix. If it moves slightly under your finger, remove it. If it holds, pour a little pool of 90% alcohol on it and then press down gently with a paper tissue to soak up the alcohol. Repeat this process several times.

Removing a mistake

In case of an accident or a mistake, you can always remove a colour. If it is still wet, wash over it vigorously with the wet eraser paintbrush and soak up the liquid with a paper tissue. If the paint has already dried, scrape it off with a small knife.

How the highlights are applied

The need to reveal a painting's inner light inspired Byzantine painters to create an original art which is simple yet knowing. This is the most complex phase of icon painting since it involves light, colour and form, but it has the advantage of being made up of a series of small stages and demands care more than virtuosity. Byzantine painting reaches its height in the depiction of figures.

☞ Preparatory exercise on paper: facial highlights

First of all, look at the final image in this short exercise (page 63), which will give you an idea of the effect of the highlights. Prepare a much thicker paint than before so that several coats of it can be applied in quick succession.

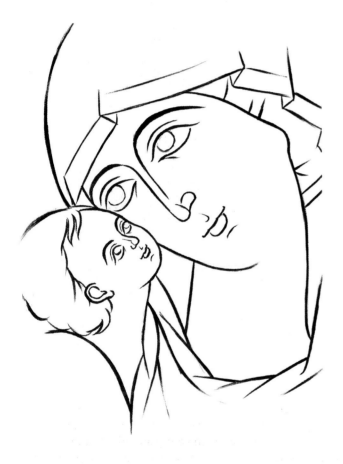

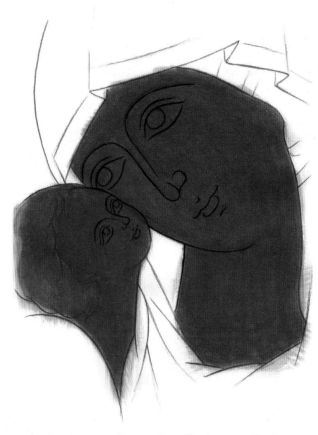

Dry-brush technique on the protoplasm. Use three coats if necessary.

1 With a pencil, copy the drawing of the Virgin's head on to watercolour paper or similar.

2 Mix 10 drops of emulsion (see page 44) with 5 drops of water. Add yellow ochre and raw umber as explained on page 57 and mix them together until you have a fairly dark but transparent tone, almost like varnish. Apply the paint to the faces using a large paintbrush. You may need to apply up to three coats. Paint over the areas again with burnt sienna.

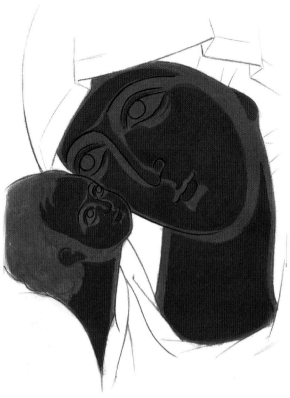

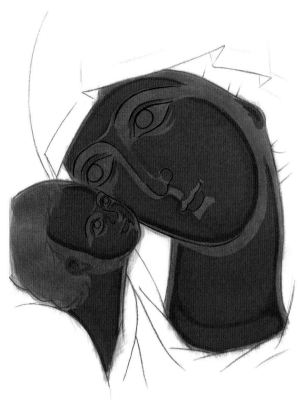

3 Mix red ochre and yellow ochre separately, adding very little water to produce an opaque mixture. For the first highlight, add a little yellow to the red.

4 The shape of the second highlight should be very accurate, so pay attention here. Add a little yellow ochre to your colour – it should be distinctly lighter but not too much. Apply it further inside the contour lines than the previous coat. Notice the detail on the forehead and neck.

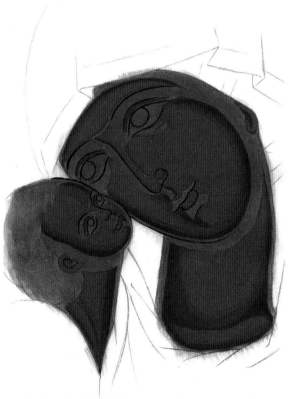

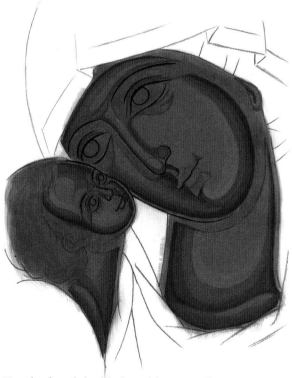

5 Apply the third highlight using a little more yellow ochre in the mix and working inside the previous area of colour.

6 For the fourth highlight, add more yellow ochre still. Yellow ochre should be distinctly the dominant colour in the mixture now.

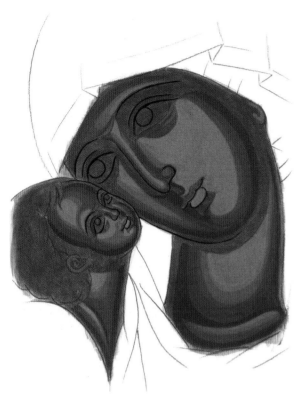

7 For the fifth highlight, use yellow ochre on its own.

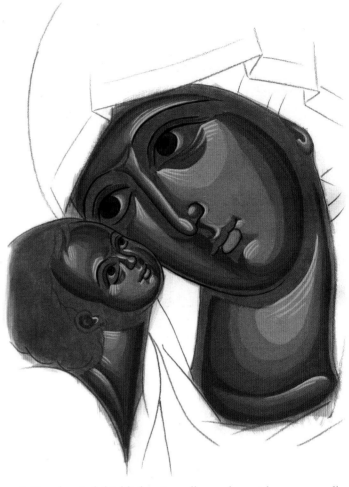

☞ Test each colour as you go, especially when working on the final highlights.

8 For the sixth highlight, tint yellow ochre with a very small amount of titanium white. Finally, using titanium white and yellow ochre, paint in the smallest, palest highlights with very thin lines. Allow the paint to dry and alter the mixture if needed. (In the illustration above, the eyes have also been completed to show the final effect.)

The exercise is finished. It can be used as a guide for painting all faces. It shows the progression of layers, which are like contours, but which express more than the shapes of the face: they reveal the life of the Spirit made flesh. The highlights on the panel have the same shape but we will work slightly differently so we can shade the colours much more gradually and subtly.

Adding the highlights to your icon

Before you start to add the highlights to your icon, follow the exercise beginning on page 61 to help you understand the systematic method involved. The highlights are applied in stages, working from dark to light tones. Leave each highlight to dry before embarking on the next. This time, the highlights are faded, or blended, to create soft transitions in some areas. The white arrows in the photographs show where to blend. Read through all the instructions before you begin, and keep a second brush, loaded with water, on hand for the blending process.

☞ Rest your working hand on a piece of paper or cloth to protect surfaces that have already been painted or gilded. As far as possible, avoid touching the panel except with the brush.

Adding the first flesh-tone highlights

1 Go over the contours of the face before you begin (see photograph 1).

2 Prepare a mixture of red ochre with a very little yellow ochre (see page 57), mixing it so that the paint is semi-transparent and thicker than the paint used for the skin base tone. It is not necessary to decant it, but once it has settled, load your wet paintbrush by laying it on the surface of the liquid and allowing it to suck up the paint. When you are close to the deposit at the bottom of the jar, abandon the mixture and prepare a new batch.

3 We have already seen where to apply highlights to the face (see pages 61–63), but on the panel this is done by applying the paint in a little lake and blurring or fading the edges. Carefully draw the shape of the highlight and fill it in at the same time (photograph 2).

4 Next, without hesitation, take your second paintbrush, full of water, and apply a strip of water where you want the paint to bleed or blend. Push this water towards the inside of the pool, all along the contour line, without pressing on to the panel with your paintbrush – the water and paint will mix together (see photograph 3). The colour has the tendency to avoid the strip of water, so push it back gently and meticulously. Little by little, the blended area will appear, so that the edge of the pool has become blurred. This difficult technique contributes to the charisma of icons. Press on calmly – it takes a great deal of practice to integrate these movements.

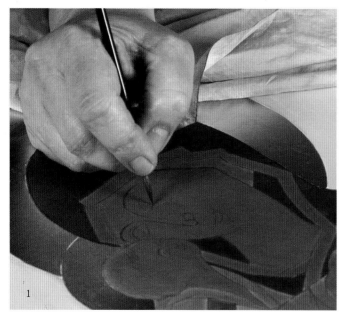

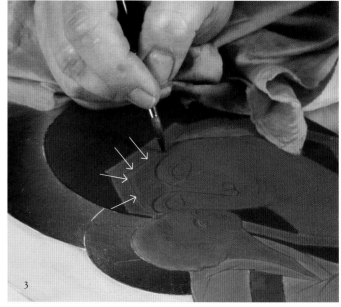

© 2004 Ecumenical Stewardship Center.
Produced by and for churches in Canada and
the U.S.A. Printed on recycled paper.
Printed in the U.S.A.
519035

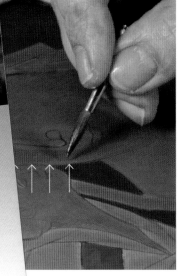

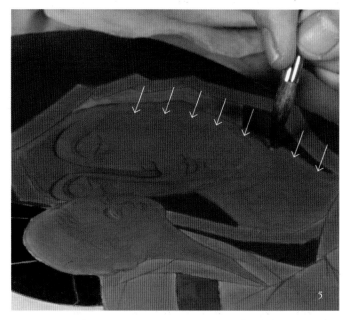

e Infant, leave a little strip
m) along the length of the

ending, and work on the

see photograph 5). This
the blending is very
large area on the side
dd highlights above the

g, indicated in
rows. Observe how it
e head.

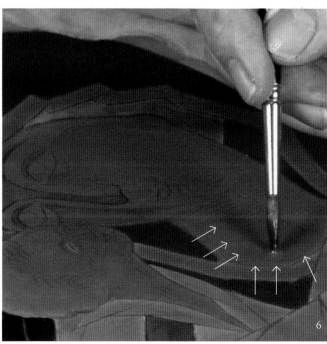

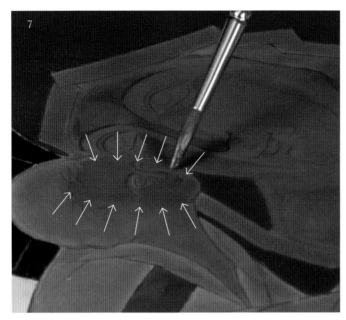

9 Paint the Infant's head in the same way as His mother's face (see photograph 7).

10 You can now move on to the hands and legs. Apply the colour in the same way as on the face, blending it at the edges as indicated in photographs 8 and 9. Each highlight will be applied three times. While the first layer of the first skin-tone highlight dries (2 to 3 hours) we will start looking at the highlights on the clothes, which are very simple on our model.

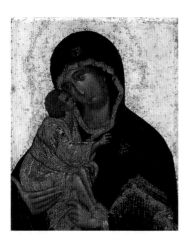

Adding highlights to the clothing

The Infant's cloak will have a special type of highlight known as an assist. This is a geometric area of gold hatching which has been selectively applied on top of the base colour and which helps bring out the volume and dynamism of the shape. These golden strokes symbolise divine energy. Paint the assist with a synthetic gold pigment or with a mix of yellow ochre and white. The importance of correctly drawing the lines of the folds will soon become clear.

1 With a semi-opaque paint, start with the flat areas around the folds, carefully observing their position and shape (see photograph 1, below). Unlike other pigments, the synthetic gold should be used from the bottom of the container. Be very careful where you place it – it is almost impossible to remove.

2 From these flat areas, draw out fine, dynamic strokes that should taper at the ends (see photograph 2). You will find it helpful to practise the movement beforehand.

3 Complete the same process on the edge of the Virgin's cloak and dress (see photograph 3). For these long strokes, try to keep your wrist firm and move your hand from the elbow. It is important to be seated comfortably and to be well balanced.

4 Repeat this process with a much more opaque paint that is still not thick.

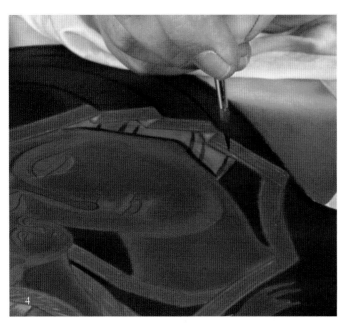

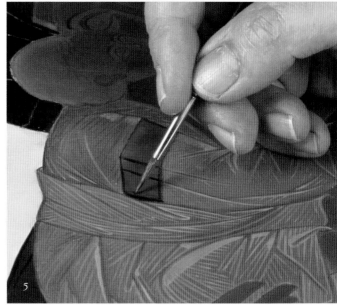

5 Now let us approach the blue surfaces: the Infant's clavus and folds of His clothes, His mother's cap and sleeve. First darken some areas with a slightly darker blue such as Prussian blue applied in quite a transparent coat with shading (photographs 4–5).

6 Once the blue coat is dry, move on to the highlights. Prepare a lighter blue colour using cobalt blue and a little titanium white and apply it as before (see photographs 6–8). Add the final highlights with synthetic gold (see photographs 9 and 10).

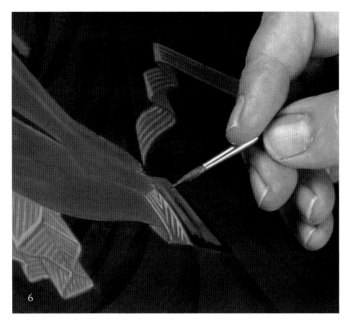

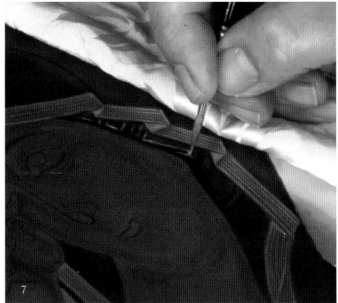

It is time to return to the highlights on the flesh tones. Once dry, the layers of red ochre from the first highlight darken. The same thing will happen with subsequent coats until the flesh tones begin to emerge from the shadows. Although the first highlight is not actually lighter, it forms the preparatory layer for the subsequent highlights; it warms the later highlights and if it is absent they would take on a greenish tint.

Adding the second flesh-tone highlights

1 For the second highlights, add just enough yellow ochre and emulsion to your previous colour to lighten it. Allow the colour to settle, as usual, and then apply the paint, creating little lakes that extend a little way back from the edges of the first highlights. Use the photographs here to help guide you and, as before, blend the colour at the edges to create a gentle transition. (The arrows in the photographs indicate where to blend.)

 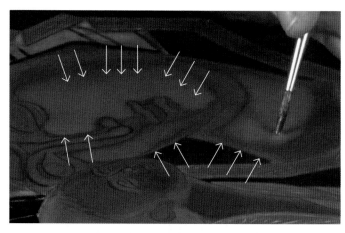

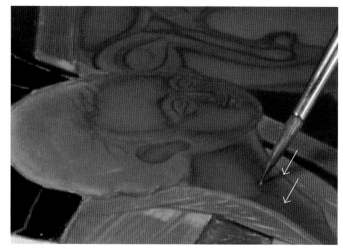 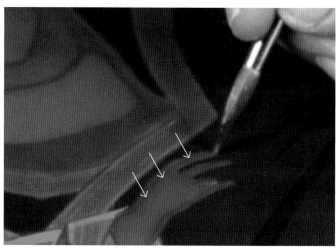

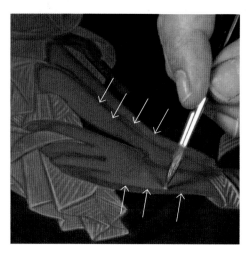 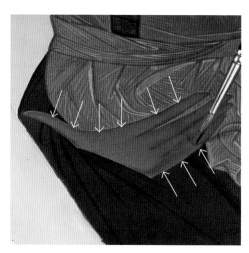

Apply the second highlights to the faces and hands as described on page 62 but blending as you did for the first highlights (see pages 64–66). The white arrows indicate where blending should occur.

2 Apply two further coats of this colour – this is important. Gradually, in this way, one coat after another, the icon's unique modelling will begin to emerge. The rise towards the lighter tones is slow and painstaking – be patient!

Developing the clothing

There are no highlights on the main part of the Virgin's cloak, perhaps as a sign of humility. Its simple form is indicated by the folds in the fabric.

Develop the folds of the cloak.

Apply a glaze to the whole cloak.

1 Work on the folds with a light mix of cadmium red and ivory black (see the photograph above).

2 To create depth, apply a glaze of either burnt umber or cadmium red deep mixed with a little ivory black, according to your taste, as explained here.

⚷ Making and applying a glaze

A glaze is a type of paint with more emulsion and less pigment than usual. It is applied in thin layers with a very dry paintbrush. Since the glaze is translucent, it subtly alters the colour underneath it. Make the glaze as described here, noting the following points:

• A glaze should allow the colours underneath to shine through. It influences the colours underneath but should not block them out.

• Several transparent glazes can be applied, but it is important that the paint does not become too thick.

• Apply the first glaze lightly and in one go and then leave it to dry so that you can assess the effect and decide if a further coat is required. Repeat with a second coat, if necessary.

1 To make a glaze, mix 12 drops of emulsion with a tiny amount of pigment using the end of a pigment knife and add 18 drops of water.

2 You can use a larger brush to apply the glaze, but it should be fairly dry. Squeeze your paintbrush well before you dip it in the glaze, and only apply a small amount of glaze at a time. Cover the surface of the cloak with the brush (see the photograph above). Only refill your brush when it is essential because it is important not to put on too much of the glaze – the less glaze applied, the more beautiful the effect. Repeat the process, as required.

Adding the third flesh-tone highlights

1 Add a little more yellow ochre to your paint – you should have a colour halfway between red ochre and yellow ochre. The process is a bit like building a staircase: the height of the steps should be regular otherwise it does not function properly. This is the final highlight for the upper eyelids.

2 To be sure of the highlight, test the colour by applying a very small amount of glaze to the end of the nose, above the eyebrow or at the top of the neck, using a 'dry' (squeezed out) paintbrush. The colour dries quickly so you can see if it has added enough light. If not, alter your mixture accordingly. As before, apply the colour three times.

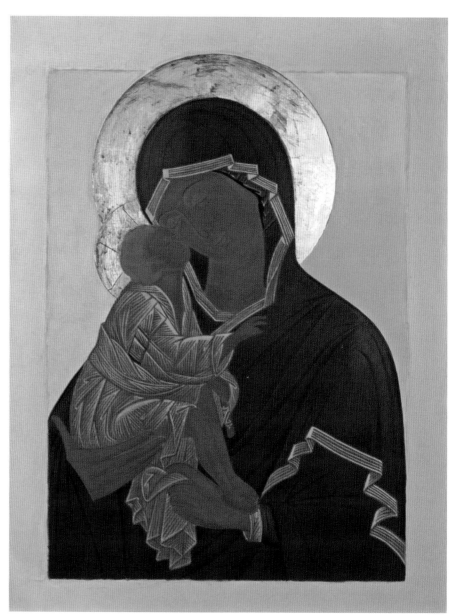

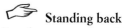 **Standing back**

Stand your panel upright as often as possible, by leaning it against a wall for example or, better still, hang it from a nail (see page 27). This will enable you to stand back from your work and contemplate its progress overall so you can see which areas may need adjustment or attention.

Adding the fourth flesh-tone highlights

Add a little more yellow ochre to your mix. As before, apply the colour three times. Drying time is shorter: 1 to 2 hours between each coat. At this stage, you will see the modelling on the necks, knees and wrists emerge.

☞ Regularly run your hand over the dry paint surface to remove any grains of pigment. If the surface is dull, brush over it with a transparent coat: 4 drops of emulsion with 6 drops of water brushed on with a very dry paintbrush.

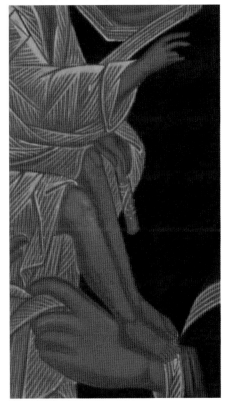

Adding the fifth flesh-tone highlights

Now start using yellow ochre on its own, referring to the photographs below. You will see things taking shape more clearly now, but be patient – there is still a way to go. As before apply three coats. At this stage the nails on the Virgin's hands will appear and the highlight on the Infant's neck becomes more apparent.

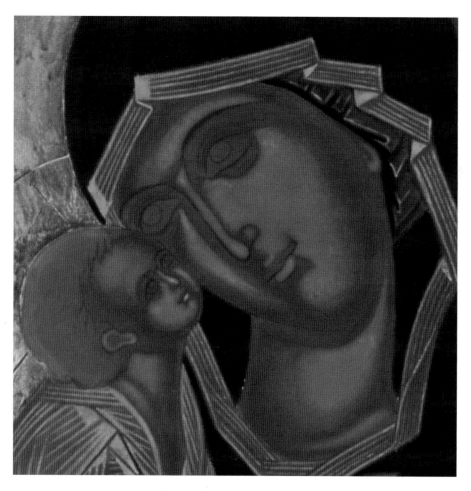

Adding the sixth flesh-tone highlights

1 First of all, apply a light glaze over the highlights to warm them up: use just a pinhead of red ochre, 4 drops of emulsion and 5 drops of water, and apply the glaze with a very dry paintbrush.

2 Next, apply light yellow ochre or yellow ochre mixed with very little titanium white, or chromium yellow and titanium white. Test your colour and then apply it using the little-lake method. This time, the difference in width from the previous highlight is more significant – the highlight is focused on specific areas of light. Use the photographs below to help you. Apply three coats that are well blended, and make the areas of the highlight progressively smaller.

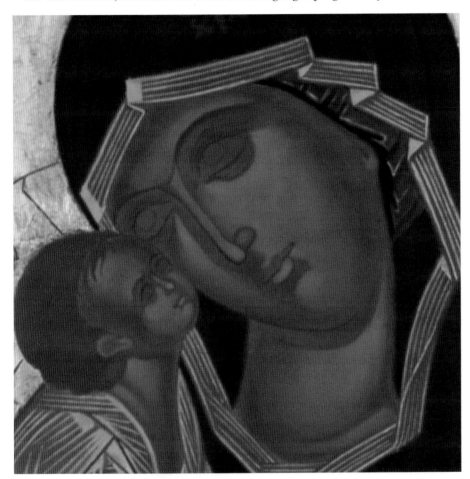

3 Work on the hands too. The middle finger and the index finger of the Virgin's right hand should each have three blended highlights (see the photograph bottom left), but leave the fingers on the Virgin's left hand as they are (photograph bottom right).

Adding the final highlights

These small drawn hatchings are achieved with the end of a fine, supple paintbrush and they will transform the figures. They are like reflections from the Kingdom of Heaven. We will apply them in two stages.

1 First, choose a paintbrush (no. 1, 2 or 3). Now mix your colour – the tone should be lighter than the previous highlight, but still golden. Test it on the panel and adjust the colour, if necessary, then make fine strokes with a very dry paintbrush: drag the brush with short, sharp movements, working from the light towards the shade (see the photographs below and opposite).

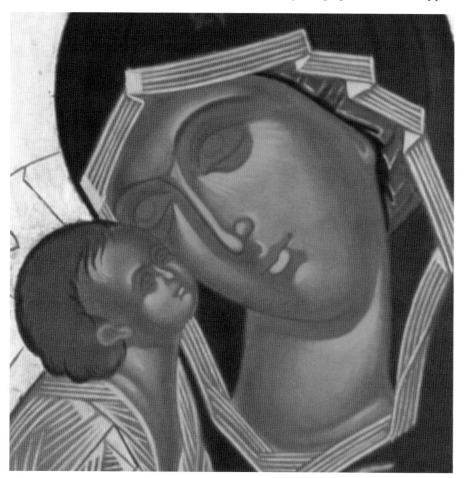

2 For the second stage, you will need yellow ochre lightened with titanium white and with just a little water in the mix so the paint is quite thick. This stage is a bit like drawing with the brush – trace the rays of light, with a very light touch, around the shapes and volumes. (For information on painting the facial features, such as the eyes, see the following page.)

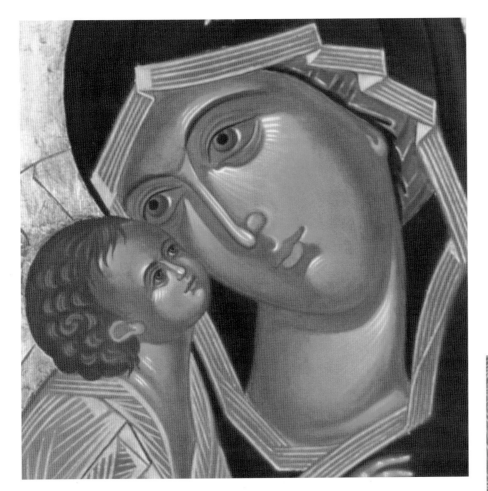

Adding the final touches to the figures

1 Go over all the contour lines on the face with a thin line of red ochre. Do the same for the hands and legs with green earth.

2 Paint the irises with transparent burnt sienna, and add a little lake of colour on the Infant's hair as shown in photograph 3.

3 Using a fairly runny mixture of white and raw umber, form a little crescent-shaped lake to the right of the irises in each of the Virgin's eyes and to the left of those of the Infant (see photograph 1). Blend this lake along its edges. Next apply a lighter and thinner layer against the iris itself.

4 With a fairly thin mixture of ivory black and burnt umber, finely underline the upper eyelids and paint the pupils (photographs 1 and 2). Underline the eyebrows with burnt umber.

5 Finally, brush a light glaze of raw umber on the base colour along the nose and under the chin.

6 For the lips, prepare 5 drops of emulsion, a tiny fleck of vermilion red and 5 drops of water. Apply a coat of this glaze to the lips of the Virgin and the Infant.

7 Using the same colour and a flat paintbrush, with hardly any paint at all, very lightly brush over the cheeks at the top of the nose, the area of contact between the two faces, the side of the nose in shadow, the fold in the upper eyelids, the chin and the neck (see photograph 2). These strokes should be hardly visible. Repeat the process a second time but cover a smaller area.

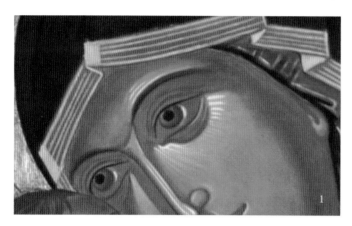

Painting the Infant's hair

In icon painting, all hair, rivers and the sea are painted with little waves. These instructions are for the Infant's hair but the technique would be the same for any hair, beard, river or sea. We will paint in four steps, leaving the paint to dry between each step.

1 Apply a transparent coat of burnt sienna to the entire area (see photograph 3).

2 Add volume to the head using a little burnt umber, blending towards the inside.

3 Paint large curved streaks using an opaque mix of red ochre and yellow ochre.

4 Finally, paint two highlights on each streak with a little more yellow ochre in your mixture (photograph 4).

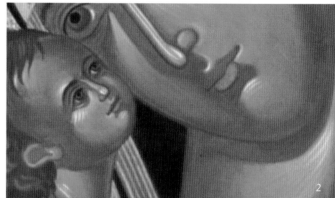

Finishing the clothing

1 There is a motif on the Virgin's cloak above the face and on the shoulder, and the cloak also has delicate gold tassels, which need to be added (see the image on page 80). To add these, first transfer the drawing on to the panel using tracing paper.

2 Paint the traced lines with a coat of opaque red ochre and leave to dry (see photographs 1 and 2).

3 Now apply gold pigment or two coats of yellow ochre over the red ochre (photograph 4, page 80).

4 Go over the contour lines on the Infant's cloak with red ochre.

5 Paint the folds of the Virgin's cloak with black mixed with burnt umber – paint a wider streak and blend it towards the inside for the contours.

6 Using the red of your choice, draw an outline with a fine stroke around the haloes (see photograph 3).

☞ To paint over the gold, replace water with ox gall.

Finishing off

Once the painting is dry, paint the sides of the panel with an opaque colour to coordinate with the room in which the icon will be hung (see page 84). All you need to do now is add an inscription (see page 115) and finally a protective coat of varnish (page 121).

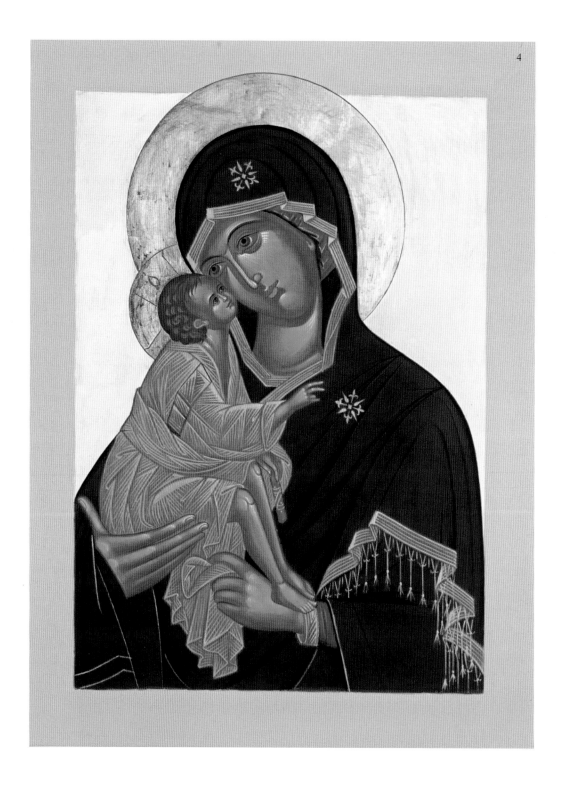

4

Using the dry-brush technique

The dry-brush technique, also known as the Greek technique, has been used since the Byzantine era, and it can be used in conjunction with the little-lake method (see page 58). The dry-brush technique allows you to work vertically on an easel, which is helpful for the quality of the drawing, especially when working on large icons, and it also makes it easier to assess how the colours appear. It can be very useful in case of problems with the gesso such as bubbles, cracks and so on. Drying times are reduced considerably with this technique.

St Jean the theologian

1 Trace your image on to the panel as described on page 46 (see photograph 1, above) then gild as required (see page 49 and photograph 2). Prepare some raw sienna egg tempera as explained on page 57, but start with a light mixture that is less liquid than the paint used for the little-lake method. Test the colour on shiny paper or on a piece of white melamine-faced chipboard.

2 Paint over the area to be covered with a clear mix made from one part emulsion to two parts water.

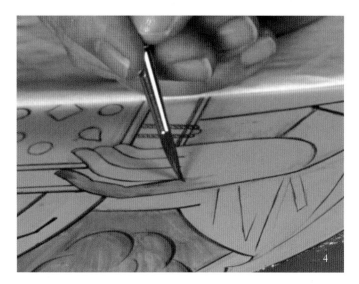

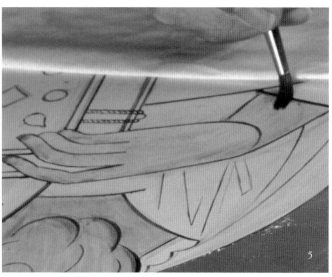

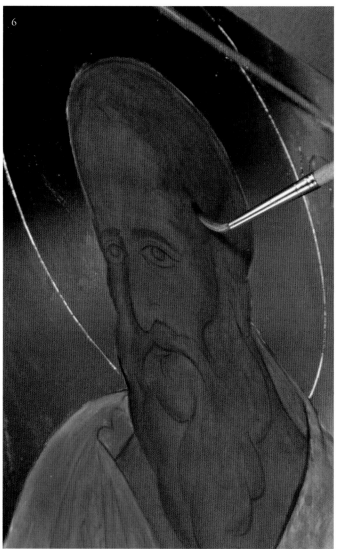

3 We will be painting the flesh tones first. Squeeze out excess paint from an artist's sable paintbrush with your fingers (see photograph 3, page 81) and brush the surface area with the raw sienna paint. Using short strokes and a light but generous touch, follow the outlines of the shapes. This requires patience – find the right movement and ensure you always use it. As with the little-lake method, start with the face and then move on to the hands (see photographs 4 and 5).

4 Apply the second and third coats of this shadowy base layer, aiming to direct the paintbrush in the opposite direction to the brushstrokes used for the first coat. After 5 to 7 coats of this base colour, apply a very light glaze of green earth with raw umber around the forehead and cheek, along the nose and on the beard (see photograph 6). For information on making a glaze, see page 71.

5 🔑 Regularly run your hand over the dry paint surface to remove any grains of pigment. If the surface is too dull, brush on a transparent layer using a mix of 4 drops of emulsion plus 6 drops of water.

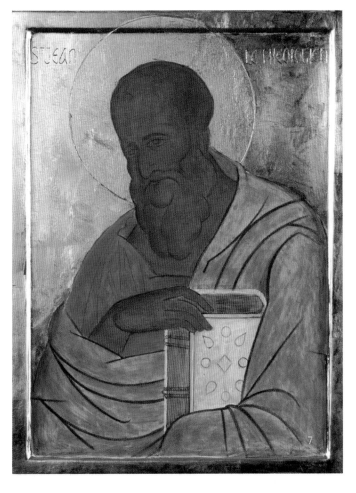

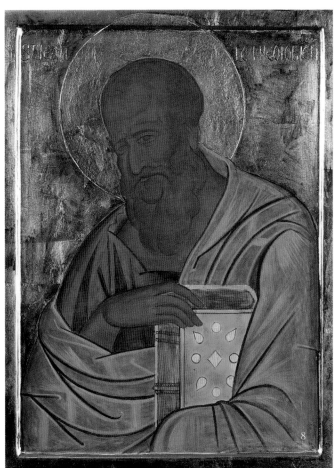

6 Now paint the base layer of the tunic, using cerulean blue (see photograph 7). For the cloak, use raw umber mixed with some yellow ochre (photograph 7).

7 Use Prussian blue to add the darker areas of the folds on the tunic, and use Bremen green earth (or green earth with blue) for highlights on the cloak (photograph 8).

8 For the highlights on the face, using yellow ochre and vermillion (see photograph 9, right).

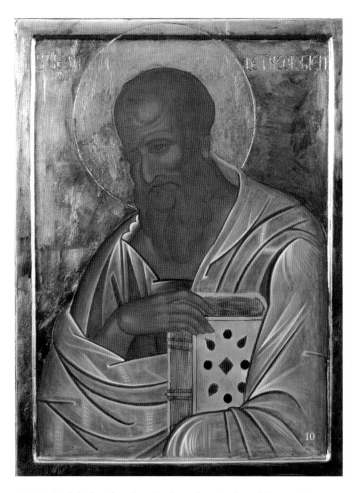

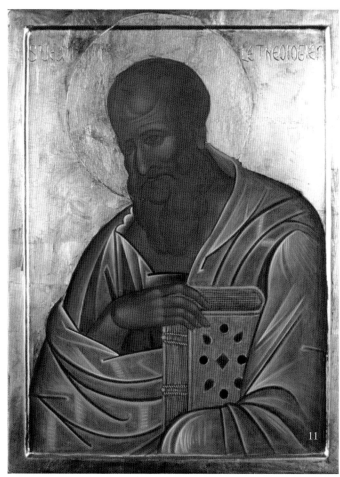

9 Mix highlights for the cloak and tunic by adding white to your base mixes and then apply them carefully (see photograph 10, above). Add yellow ochre and then white for further highlights on the skin tones (photograph 11).

10 The highlights for the beard (photographs 12 and 13) require raw umber plus white, then white on its own. Although the method of application is different, the positioning of the highlights is the same as when adding highlights using the little-lake method (see page 78).

11 Paint the side of the panel using a large brush and a colour to complement the room in which the icon will be hung (photograph 14). Take special care when painting the front edge (photograph 15).

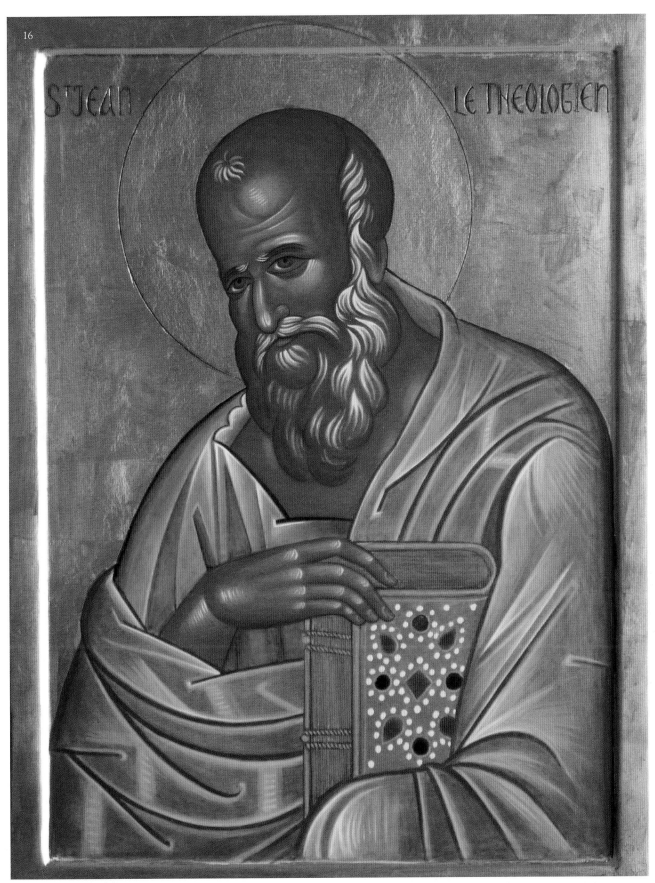

16

ST JEAN LE THEOLOGIEN

12 The finishing touches should be completed in a similar way to those we used when painting *Our Lady of the Don* (see pages 79–80).

Other icons, stage by stage

The following five icons, shown stage by stage should help clarify the painting process for different subjects.

Presentation of the Virgin to the Temple

1 Transfer the image and draw it with a paintbrush.

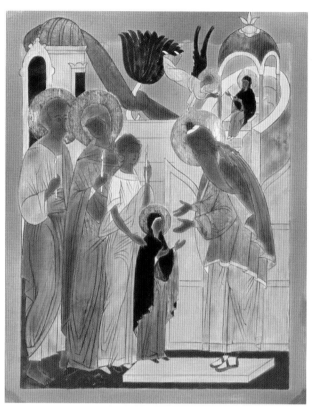

2 Apply the shadow/base colours.

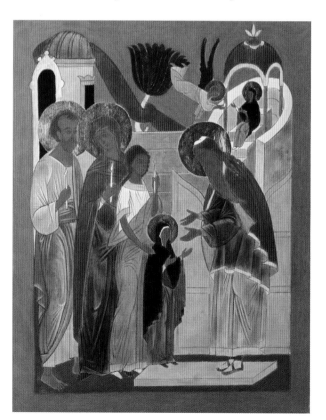

3 Start on the highlights.

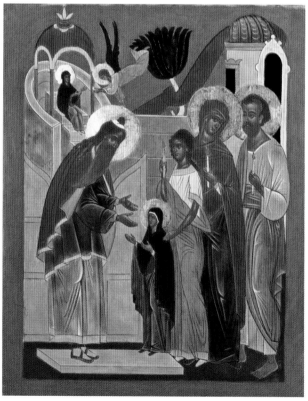

4 Gradually use lighter and lighter tones.

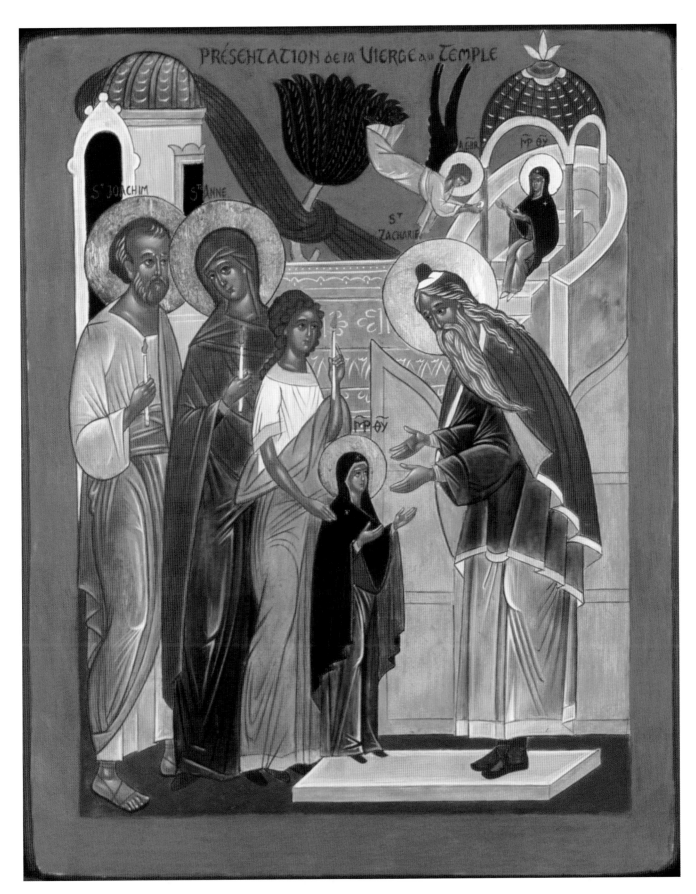

5 Add the final lights and contours then add the inscriptions.

1 Transfer the image and draw it with a paintbrush. Apply the gold.

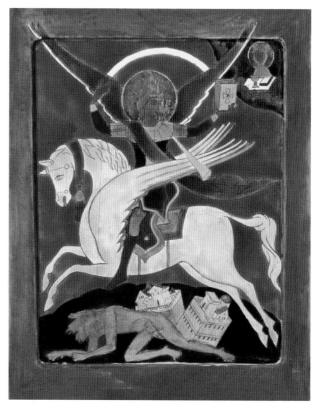

2 Apply the shadow/base colours.

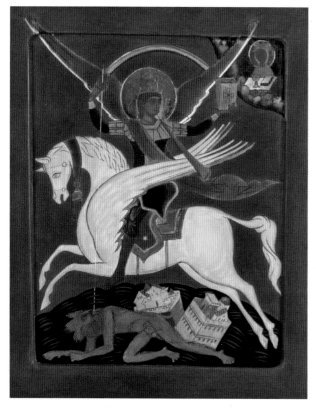

3 Start on the highlights.

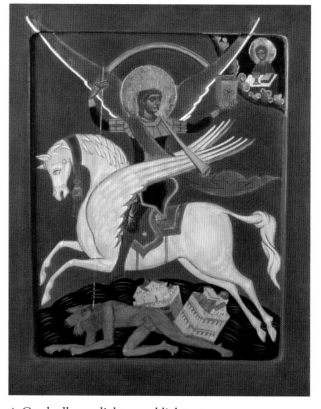

4 Gradually use lighter and lighter tones.

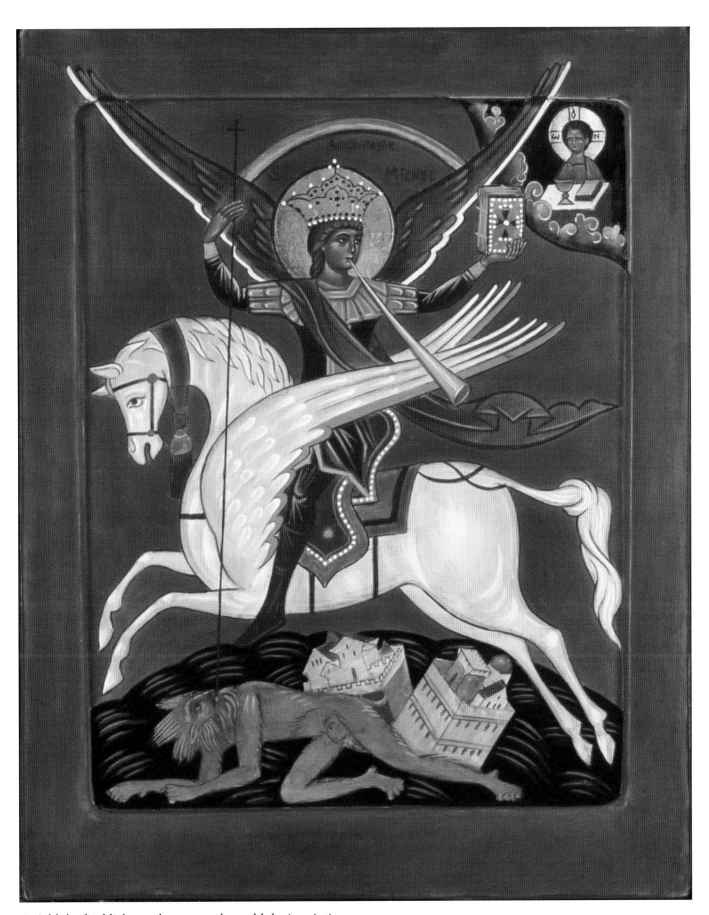

5 Add the final lights and contours then add the inscriptions.

The Mother of God Enthroned

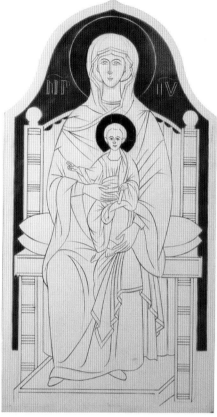

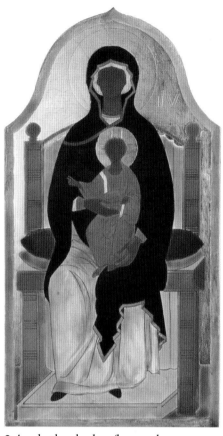

1 Transfer the image and draw it with a paintbrush. Apply the gold.

2 Apply the shadow/base colours.

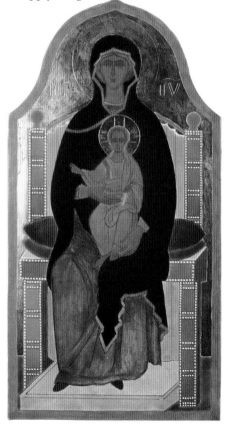

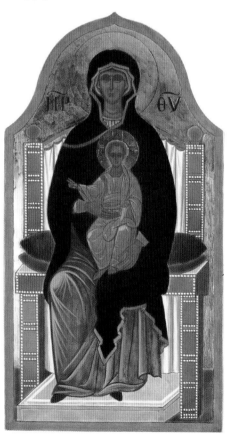

3 Start on the highlights.

4 Gradually use lighter and lighter tones.

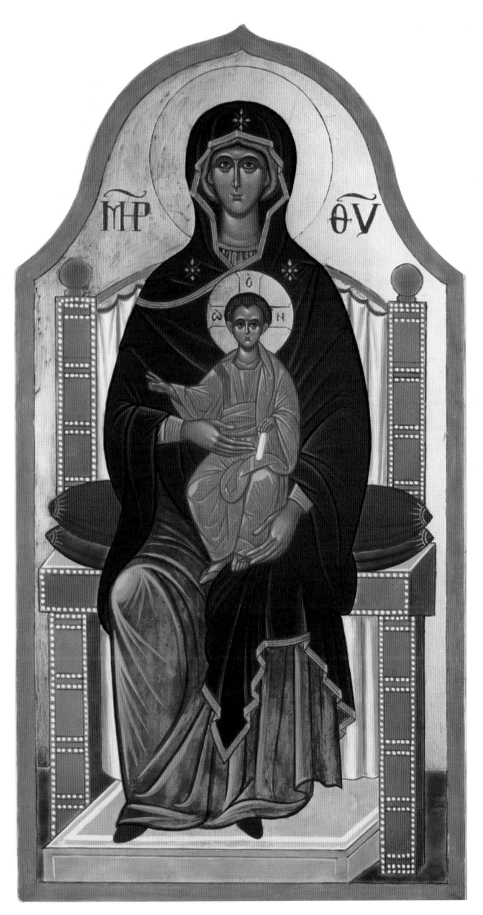

5 Add the final lights and contours then add the inscriptions.

3a Start on the highlights.

1 Transfer the image and draw it with a paintbrush. Apply the gold.

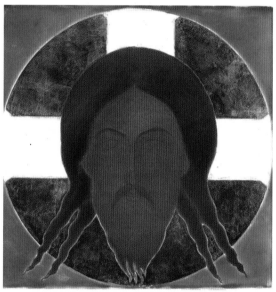

3b Continue the highlights.

2 Apply the shadow/base colours.

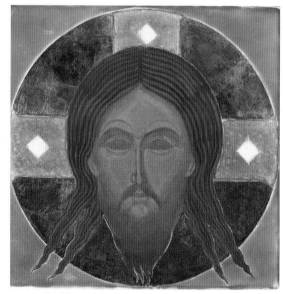

4 Gradually use lighter and lighter tones.

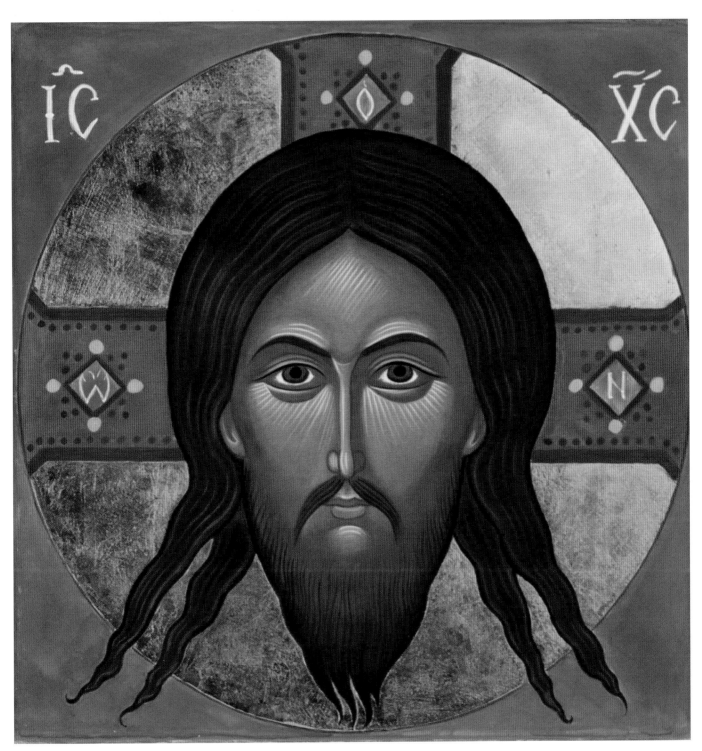

5 Add the final lights and contours then add the inscriptions.

The Saviour

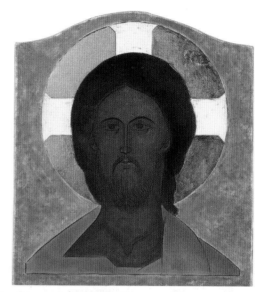

3a Start on the highlights.

1 Transfer the image and draw it with a paintbrush. Apply the gold.

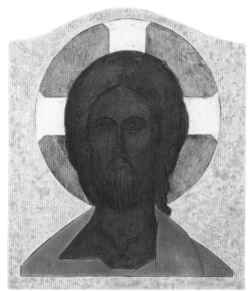

2 Apply the shadow/base colours.

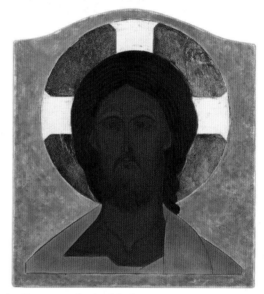

3b Continue the highlights.

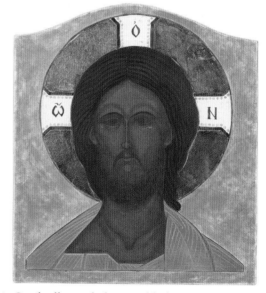

4 Gradually use lighter and lighter tones.

94

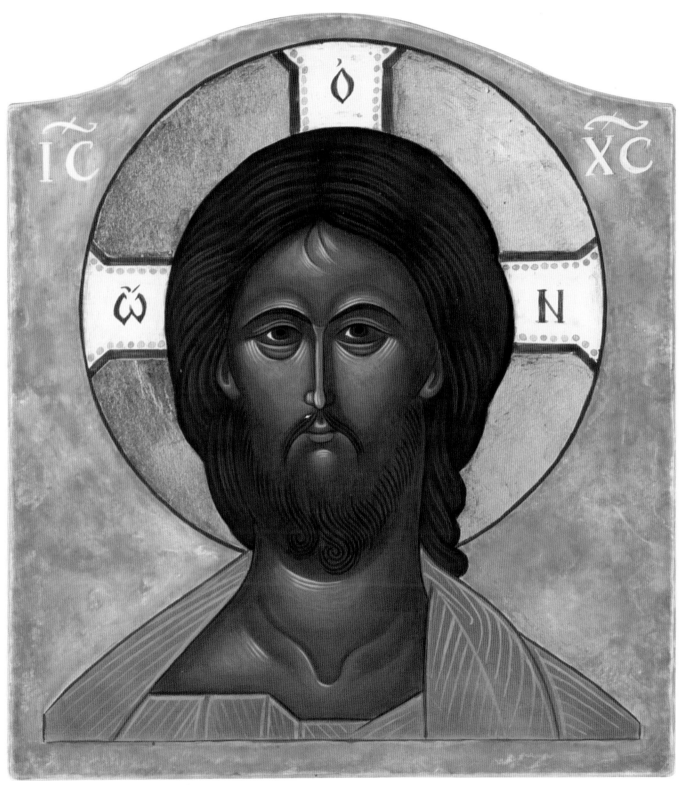

5 Add the final lights and contours then add the inscriptions.

Gallery

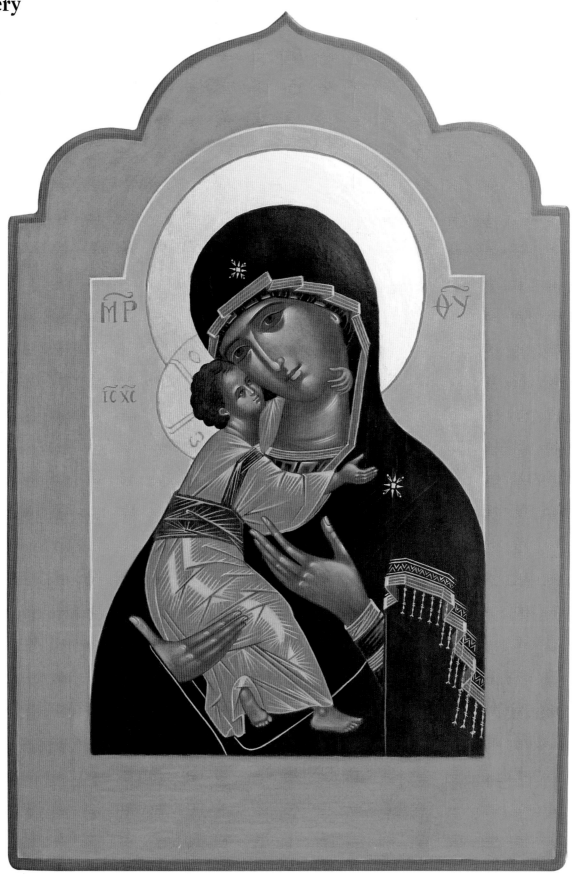

Virgin of Vladimir, or *Our Lady of Tenderness*.

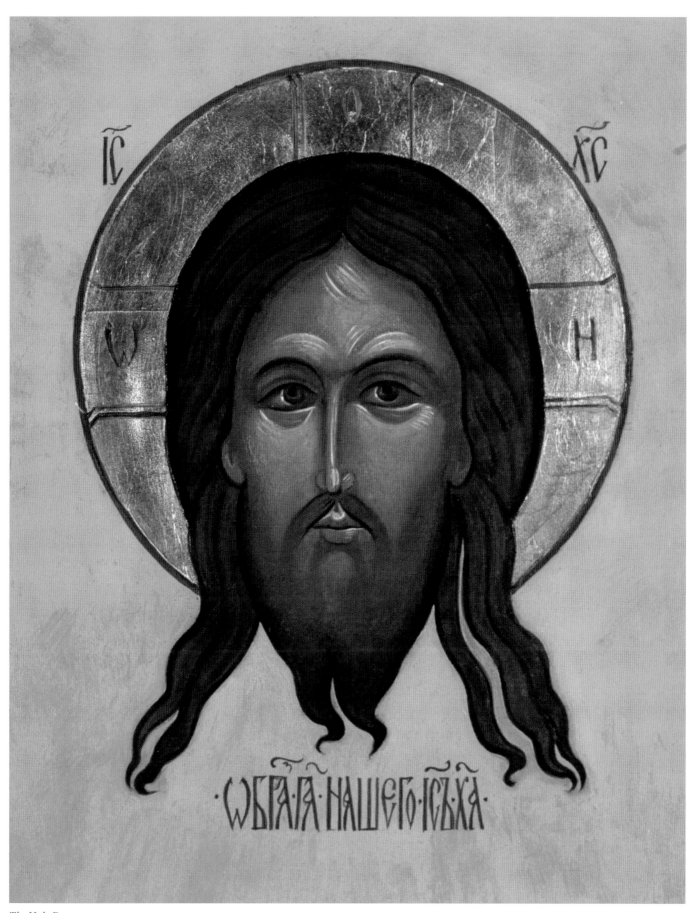

The Holy Face.

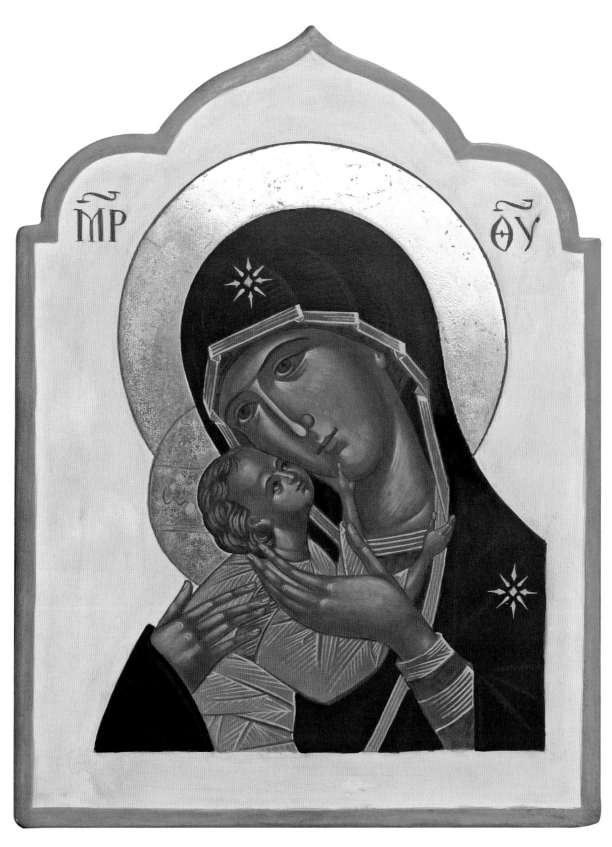

Mother of God of Tenderness.

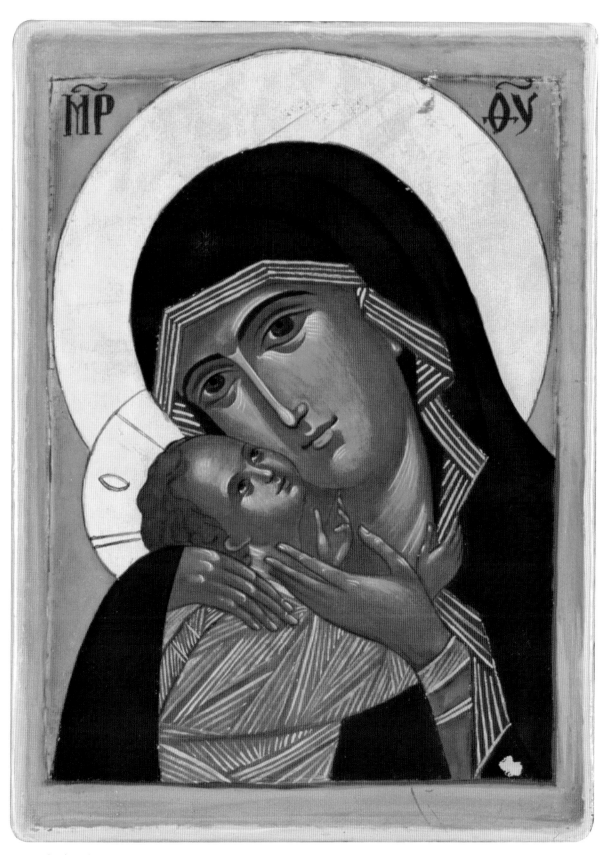

Our Lady of Tenderness.

Saint Elisabeth of Hungary.

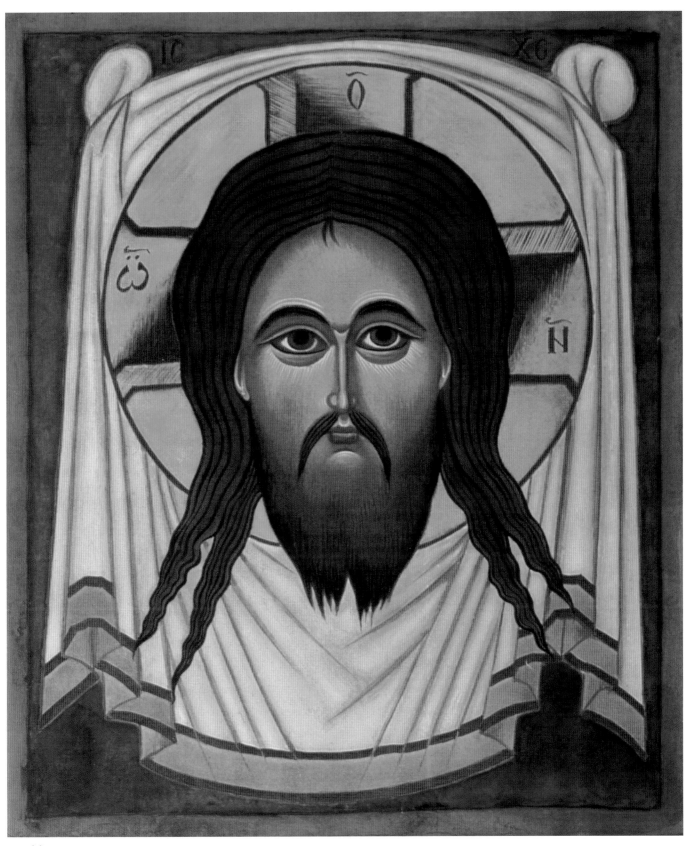

Mandylion.

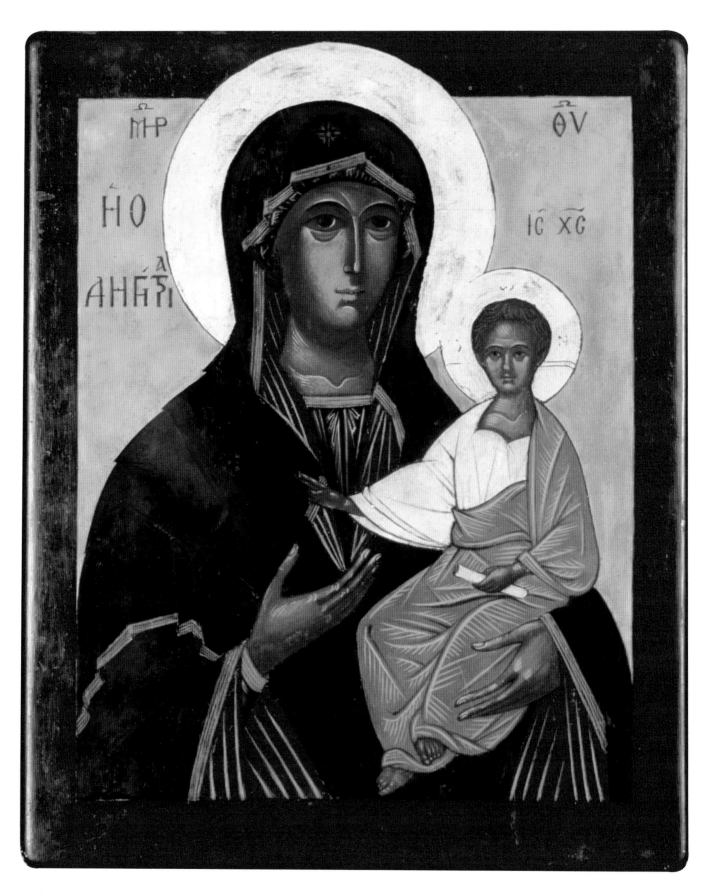

Virgin Hodegetria.

102

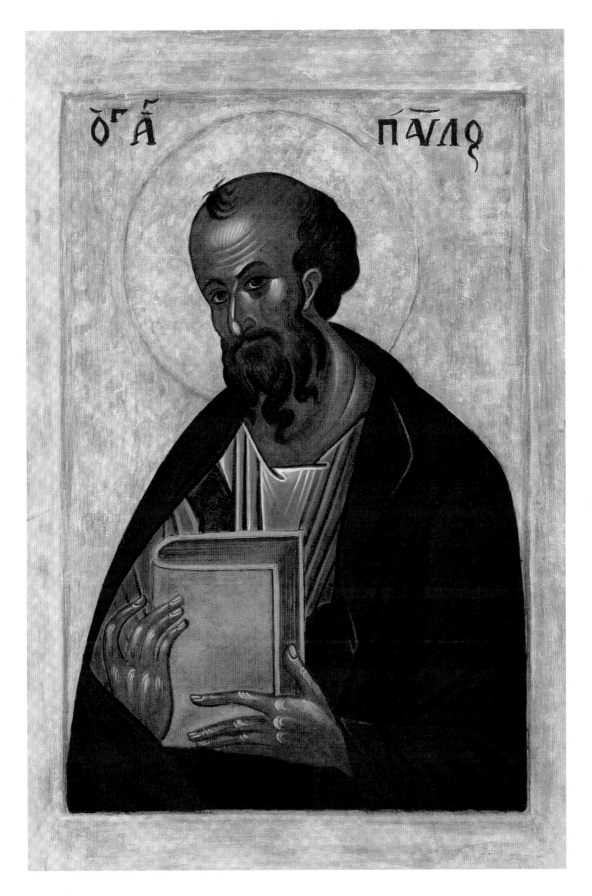

Saint Paul.

103

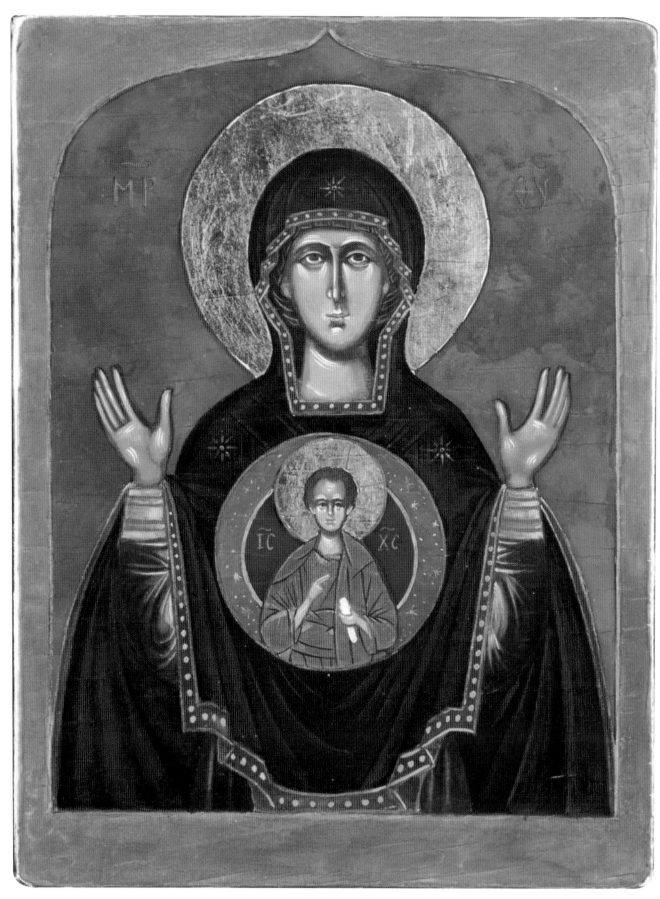

Virgin Orans.

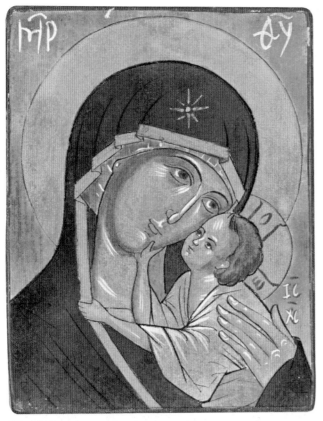

Virgin by Laroslav.

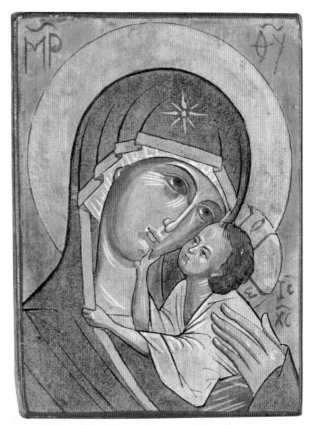

Virgin by Laroslav.

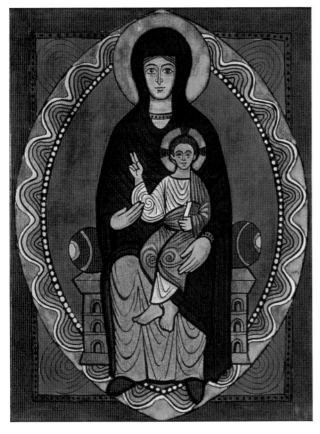

Roman Virgin.

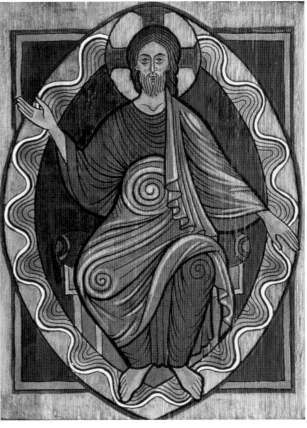

Roman Christ.

105

Gallery of students' icons

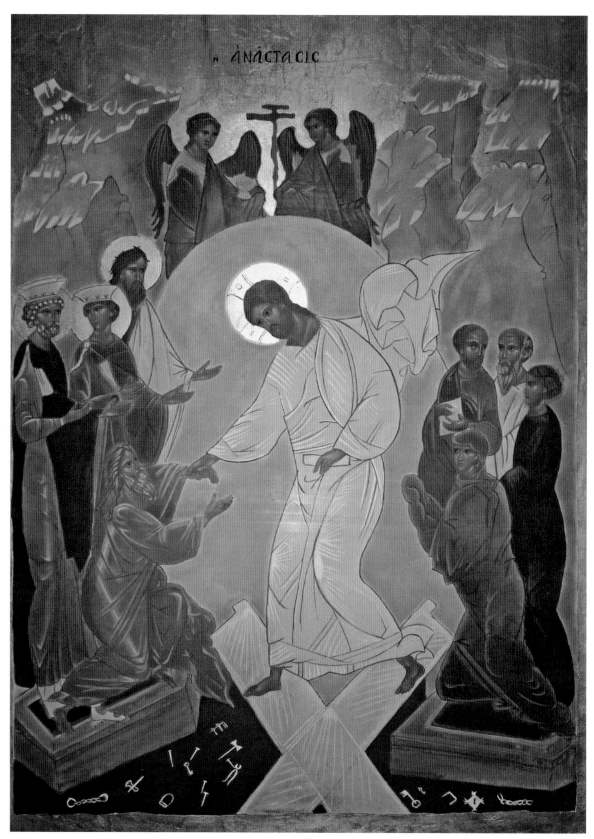

The Resurrection.

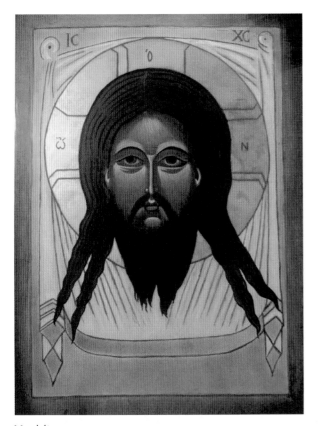

Mandylion.

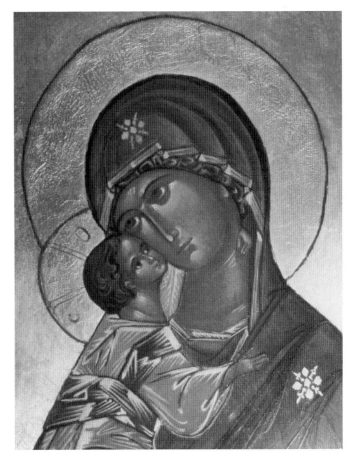

Mother of God by Vladimir.

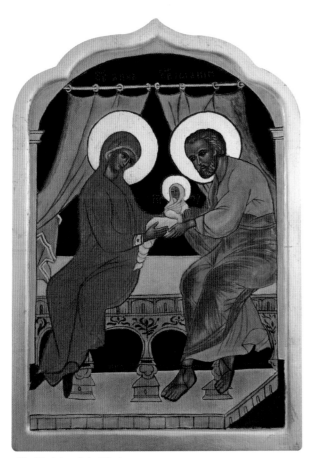

The Nativity of the Virgin.

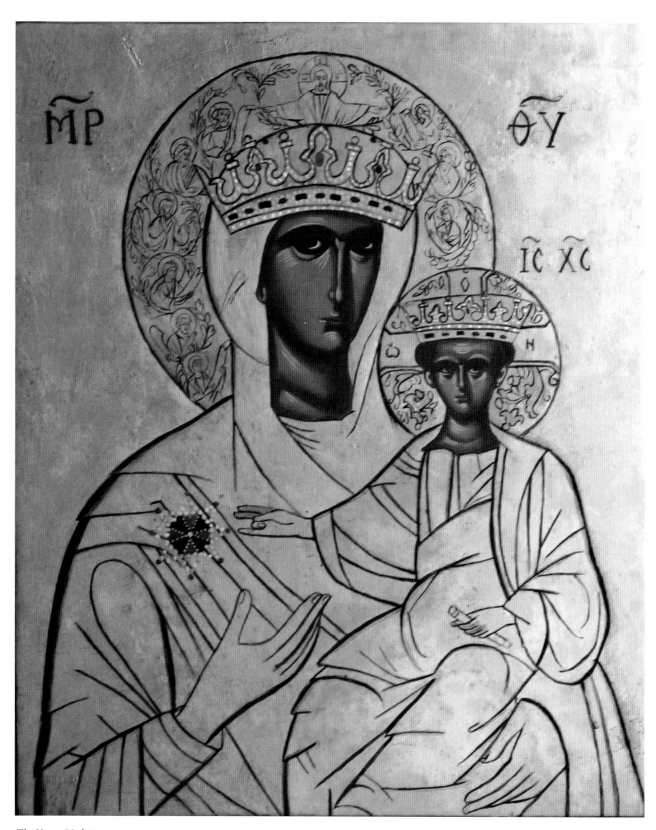

The Virgin Mediator.

Saint George.

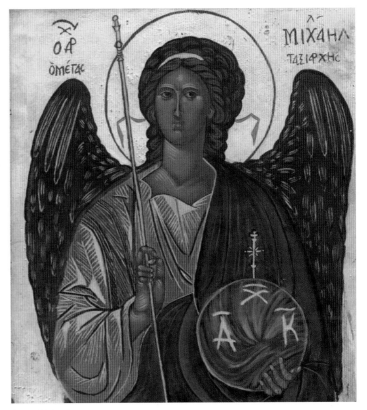

Saint Michael.

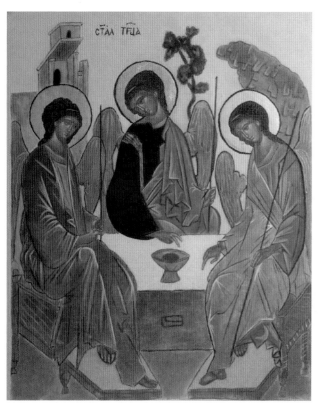

The Holy Trinity.

The Baptism of Christ.

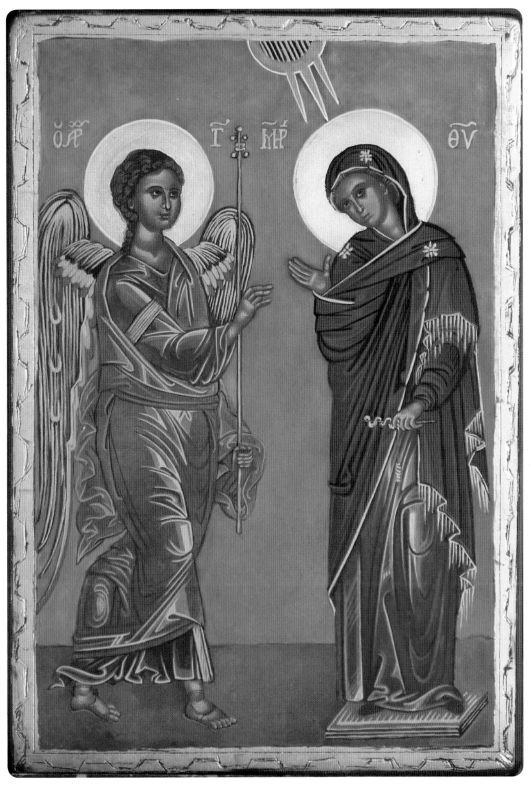

The Annunciation.

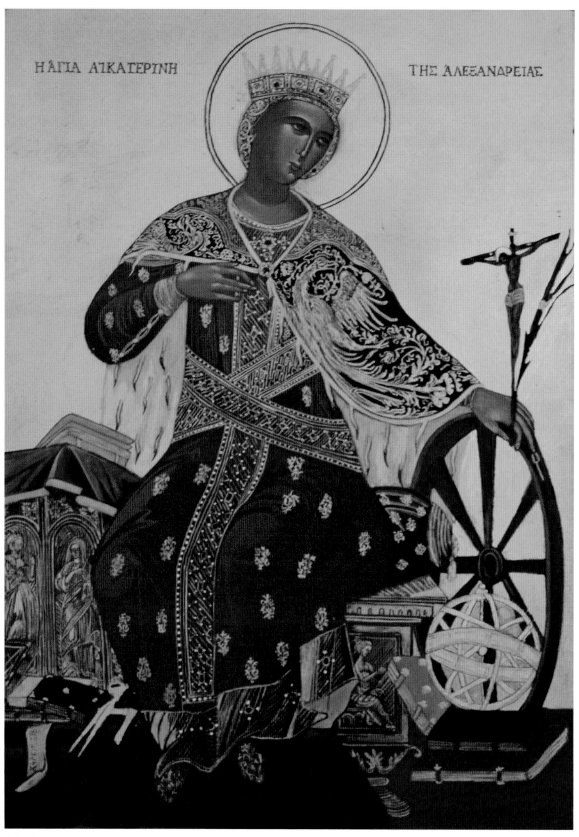

Saint Catherine.

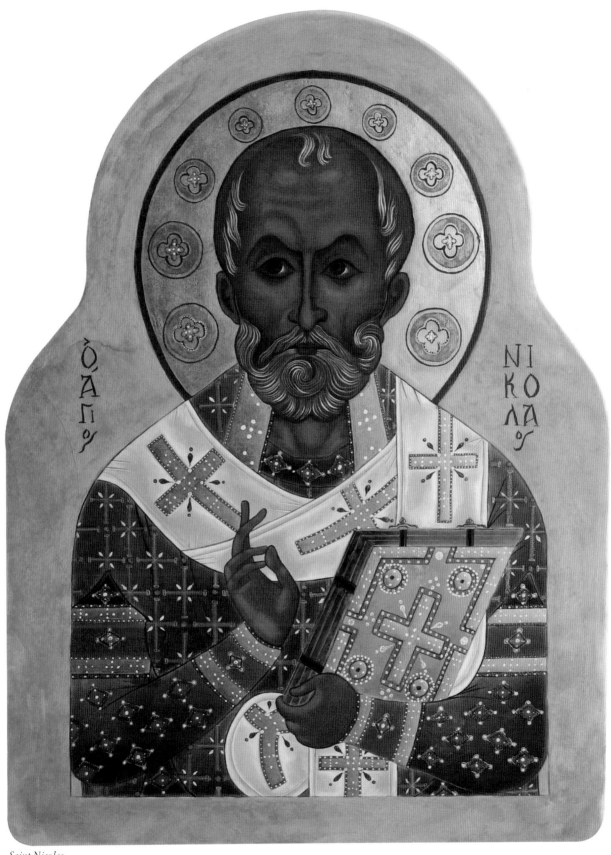

Saint Nicolas.

113

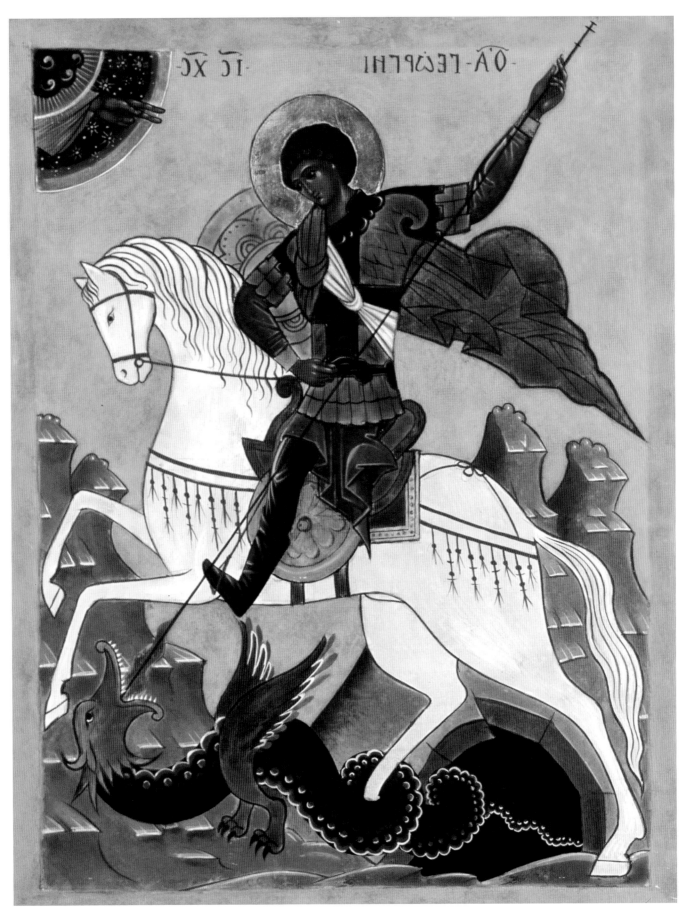

Saint George.

8 *Inscriptions*

Adding the name

Our painting is not an icon until it receives its name or inscription: the inscription that links the work to the saint it represents. Inscriptions on ancient icons are written in the languages of Byzantine liturgies, but many iconographers today use one of the modern languages. Add the name as follows:

1 Mix up your paint: the colour mixing for calligraphy work follows the same process as that for drawing (see pages 44–47).

2 Trace the lettering with very fine lines (see page 43).

3 Paint over the traced lines using downstrokes and upstrokes.

To draw over gold, replace the water in the mixture with ox gall. Once it has dried, fix the inscription with a little white shellac.

'Jesus Christ': IC XC.

In the halo: 'I am the one who is'

'The Mother of God: **MP ΘY**

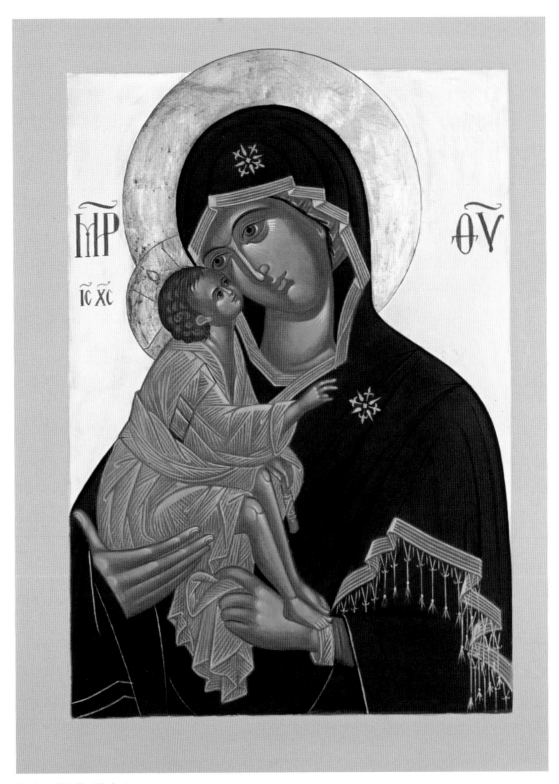

Mother of God by Vladimir.

Examples of inscriptions

LA NATIVITÉ de LA MÈRE de DIEU The Nativity of the Mother of God

Ὁ ΓΕΝΕCΙΟΝ ΤΗC ΘΕΟБΚ̄Υ Greek

РОЖДЕСТВО́ ПРСТЫ҇ Б҇ЦЫ Slavonic

LA PRÉSENTATION de LA VIERGE au TEMPLE The Presentation of the Virgin at the Temple

ΤΑ ΕΙCΟΔΙΑ ΤΗC ΘΕΟБΚ̄Υ Greek

ВХО́Д ВО ХРА́МZ ПРСТЫ҇А Б҇ЦЫ Slavonic

L'ANNONCIATION The Annunciation

Ὁ ΕΥΑΓΓΕΛΙCΜΟC Greek

БЛАГОВѢ́ЩЕНЇЕ Б҇ЦЫ Slavonic

LA NATIVITÉ The Nativity

Ἠ ΧΡΙCΤΥ ΓΕΝΝΗCΙC Greek

РОЖДЕСТВО́ Г҇ДА НАЩЕГѠ Ї҇ИСА Slavonic

117

LA PRÉSENTATION de JÉSUS au TEMPLE — The Presentation of Jesus at the Temple

Ἡ ΥΠΑΝΤῊ — Greek

СРѢ́ТЕНЇЕ ГДА НАЩЕГѠ ЇНСА ХРТА — Slavonic

LE BAPTÊME du CHRIST — The Baptism of Christ

Ἡ ΒΑΠΤΙCΙC — Greek

БОГОАВЛЕ́НЇЕ — Slavonic

L'ASCENSION — The Ascension

Ἡ ἈΝΑΛΥΨΙC — Greek

ВОЗНЕСЕ́НЇЕ — Slavonic

LA TRANSFIGURATION — The Transfiguration

Ἡ ΜΕΤΑΜΟΡΦѠCΙC — Greek

ПРЕѠБРАЖЕНЇЕ — Slavonic

L'ENTRÉE à JÉRUSALEM — Entry into Jerusalem

Ἡ ΒΑΪΟΦΟΡΟC — Greek

ВХОД ГДЕНЪ ВЪ ЇЕРУСАЛИМЪ — Slavonic

ÉLEVATION DE LA CROIX The Elevation of the Cross

Ἡ ὝΨΩϹΙϹ ΤΫ ΤΙΜΙΫ ϹΤΑΥΡΫ Greek

ВОЗДВИЖЕНІЕ КРСТА ГДНА Slavonic

LA RÉSURRECTION The Resurrection

Ἡ ἈΝΆϹΤΑϹΙϹ Greek

ВОСКРЕСЀНІЕ ХР̂ТОВО Slavonic

LA SAINTE TRINITÉ The Holy Trinity

СТ̂АА ТР̂ЦА Slavonic

LA PENTECÔTE The Pentecost

Ἡ ΠΕΝΤΕΚΟϬῊ Greek

СОЩЀСТВІЕ СВѦТА́ГО Д̂ХА НА АПОСТОЛОВЪ Slavonic

LA DORMITION DE LA MÈRE DE DIEU

The Dormition of the Mother of God

Ἡ ΚΟΊΜΗϹΙϹ Greek

ОУСПЀНІЕ ПР̂СТ̂БѦ Б̂ЦВ Slavonic

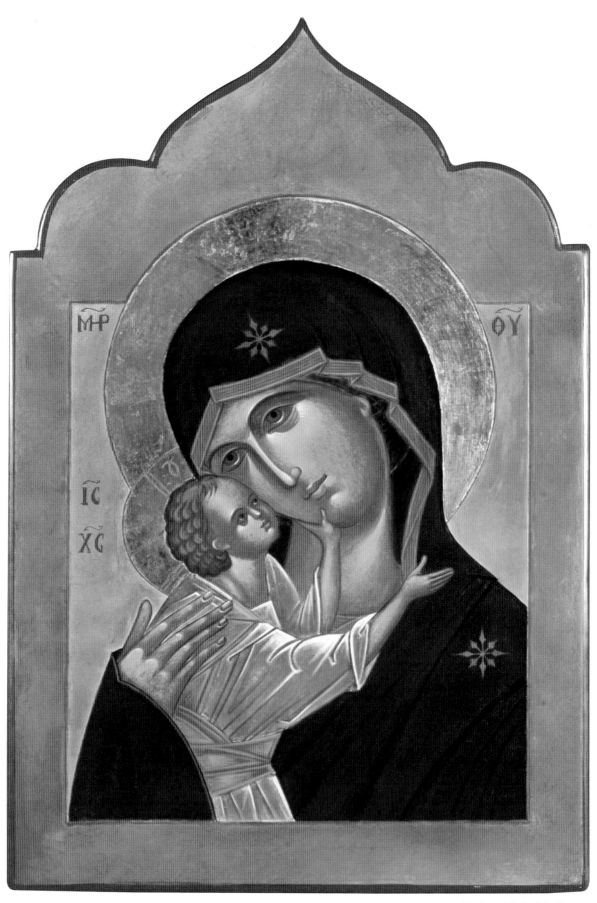

Mother of God of Tenderness.

9 Olifa and varnish

Egg tempera dries to become hard and insoluble – it has no known solvent. But the paint can be scuffed, dirtied or marked and the surface is still susceptible to humidity. It is therefore essential to apply a protective film over the painted surface. This finishing touch slightly alters the appearance of the colours and the overall impression given by the icon. If it is too shiny, it brings out the colours but the icon cannot be seen from all angles. Whatever varnish you choose, allow the egg tempera to dry for at least 3 to 6 months before you apply it, and in the meantime apply a protective unifying and preparatory coat: the pre-varnish.

Pre-varnishing with egg yolk
1 Make a mix of one part emulsion (see page 44) to one part water and lightly brush it over the final highlights on your icon.

2 On the following day, apply a thin, vertical coat of the pre-varnish over the whole surface except the gilded areas.

3 A week later, brush on another thin layer, this time working with horizontal brushstrokes.

4 A week later, apply a vertical coat. Leave to dry for three weeks and then rub over the surface using a pair of tights tied into a ball.

Note: Store your icon out of the way of flies while the pre-varnish dries because the insects are partial to the egg. When the picture becomes as hard as stone, the flies will no longer be attracted.

Pre-varnishing with egg white
1 Whisk an egg white until stiff. Pour a small glass of water on to it, cover the mixture and leave it until the following day. We will use the liquid that has settled at the bottom.

2 Apply a fairly small quantity of the mixture with a large, soft paintbrush. Do not put too much egg white on the gilded areas.

Olifa

This is the traditional varnish used to protect icons. Since the olifa penetrates each layer of paint, it helps light to reach inside the icon, which improves the transparency and vivacity of the colours, as if the image is awoken.
The technique is restrictive and sometimes criticised because the oil has the tendency to oxidise and attract dirt over time, but it is a symbolically meaningful process. It gives an attractive satin appearance. You can protect the coat of olifa with a shellac varnish or with a wax polish.

Before applying olifa, the tempera should be completely dry and even the final lights, the finishing touches and inscriptions should be solid. This will take around six months. A pre-varnishing is recommended. If you have not used this varnish before, it is strongly recommended that you try it out on some practice panels before using it on your icon. Gold leaf can cause difficulties with this varnish and it is vital that the tempera and pre-varnish are fully dry.

Applying olifa

My recipe: 75% boiled linseed oil to 25% Dammar varnish plus 0.3% cobalt acetate. Gently heat the mixture in a bain-marie.

Work in dry weather, preferably on a sunny day. Your panel and the working area should be perfectly dust-free, and avoid wearing clothes that could shed fibres or spread dust such as woollens.

1 Heat up the olifa – it will penetrate the panel more easily when warmed. Cover the icon with a generous coating of olifa and rub it in gently. Allow the oil to seep in for an hour and then rub the surface again to distribute the liquid. Areas with twenty layers of paint absorb the oil better than those that only have two.

2 Remove any excess olifa by rubbing the surface and repeatedly wiping your hands on silk paper. Repeat this process every half hour until the oil begins to take. The olifa should have been absorbed by the paint.

3 Allow the varnish to dry for three months away from any source of dust. Repeat the process on any areas that were not covered.

Varnishes

Can all varnishes protect the icon? We now know that modern varnishes made from synthetic resins and solvents are dangerous for human health even once dry. This is, of course, completely incompatible with the icon's function. For this reason I will deal only with the traditional varnishes, which are more natural.

Alcohol-based varnishes

White or blonde shellac is much used among iconographers. It is not very resistant but it protects the painting from humidity very effectively. It can leave a slightly glossy shine that can be improved with a layer of wax. It should be diluted with varnishing alcohol and spread quickly using a large, soft brush. Allow 15 minutes drying time.

Copal or resin varnishes are harder, and produce an amber-like colour. They are applied in the same way as shellac. As with shellac, allow 15 minutes drying time.

Oil varnishes

These are plant-based resins that have been dissolved in a solvent. The tempera should be completely dry and pre-varnished before applying this type of varnish. Apply the varnish in dry weather, in thin coats, and allow eight days drying time. Dammar varnish is fairly shiny and colourless.

Mastic varnish is harder, but more coloured and more expensive. It can replace Dammar in the olifa.

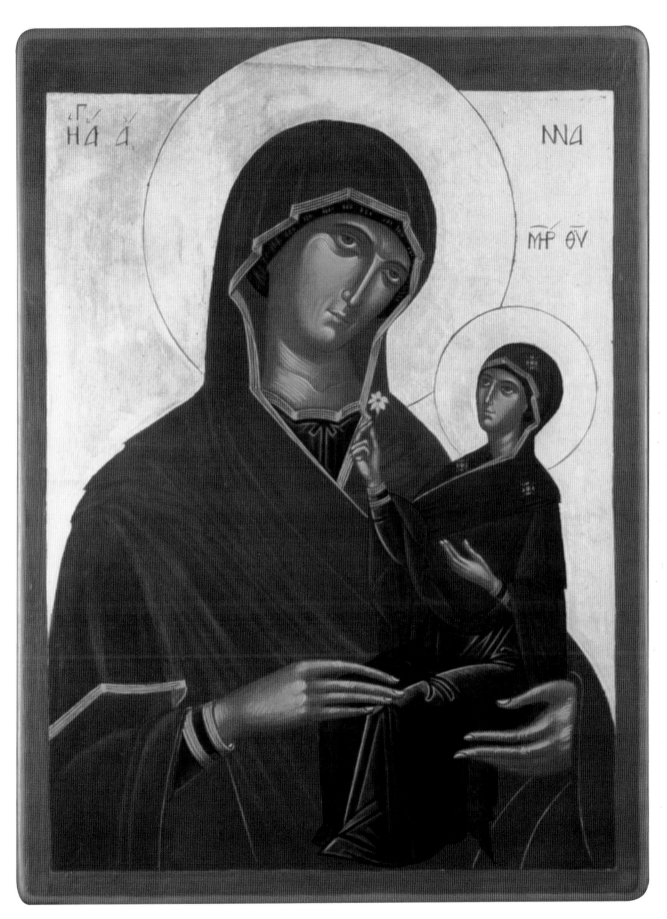

Saint Anne and the Virgin.

Descent from the Cross, by Genviève Gouverneur.

Bibliography

Egon Sendler, *L'icône image de l'invisible [The Icon: Image of the Invisible]*, Desclée de Brouwer, 1981.

Léonide Ouspensky, *Théologie de l'icône [Theology of the Icon]*, Cerf, 1980.

Père Paul Florensky, *La perspective inversée [The Inverted Perspective]*, L'Age d'Homme, 1992.

Michel Quenot, *L'Icône [The Icon]*, Cerf, 1987, *De l'icône au festin nuptial [From Icon to the Nuptial Feast]*, Cerf, 1999, *Dialogue avec un peintre d'icônes [Conversation with an Icon Painter]*, Cerf, 2002.

Moine Grégoire, *Carnets d'un peintre d'icônes [An Icon Painter's Notebooks]*, L'Age d'Homme, 1983.

Père Georges Drobot, *Icône de la Nativité Abbaye de Bellefontaine [The Christmas Icon]*, 1993.

Jean-Claude Larchet, *L'iconographe et l'artiste [The Iconographer and the Artist]*, Cerf, 2008.

Alfredo Tradigo, *Icônes et saints d'Orient [Icons and Saints of the Eastern Orthodox Church]*, Hazan, 2005.

Ol'ga Popova, Engelina Smirnova, Paola cortesi, *Les Icônes [Icons]*, Solar, 1996.

Père Simon Doolan, *La redécouverte de l'icône [The Rediscovery of the Icon]*, Cerf, 2001.

Jean-Yves Leloup, *L'Icône une école du regard [The Icon, a Way of Seeing]*, Le Pommier, 2001.

Viktor Nikitic Lazarev, *Icônes russes [Russian Icons]*, Thalia, 1996.

Mahmoud Zibawi, *L'icône [The Icon]*, Desclée de Brouwer, 1993.

Images de la spiritualité grecque [Images of Greek Spirituality], Skira, 2004.

Le Mont Athos et l'Empire byzantin [Mount Athos and the Byzantine Empire], Paris-Musées, 2009.

Saint Mammes.

126

WITH THANKS

To my father, who passed down to me his love for this art.

To Geneviève Gouverneur, who taught me to paint icons with conscience, devotion and warmth.

To Judith.

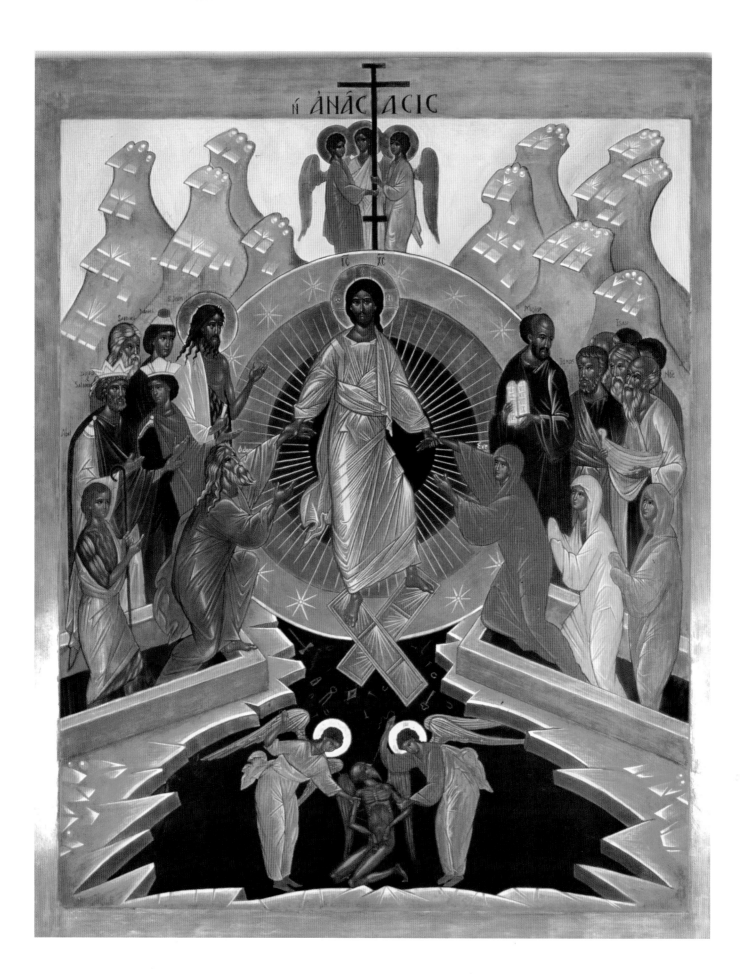